TISBURY & NADDER VALLEY

THROUGH TIME

Rex Sawyer

AMBERLEY PUBLISHING

First published 2012

Amberley Publishing
The Hill, Stroud
Gloucestershire, GL5 4EP

www.amberley-books.com

Copyright © Rex Sawyer, 2012

The right of Rex Sawyer to be identified as the
Author of this work has been asserted in accordance
with the Copyrights, Designs and Patents Act 1988.

ISBN 978 1 4456 0831 0

British Library Cataloguing in Publication Data.
A catalogue record for this book is available from
the British Library.

Typeset in 9.5pt on 12pt Celeste.
Typesetting by Amberley Publishing.
Printed in the UK.

Introduction

Rising in the chalk hills to the east of Shaftesbury, the River Nadder begins its tortuous route through some of the most beautiful pastoral country in South Wiltshire. Fed by springs from the Donheads, the Nadder links with the River Sem north of Wardour before continuing its leisurely course through such historic settlements as Tisbury, Dinton and Wilton, the ancient capital of Wessex. At Quidhampton it merges with the Wylye to join the Avon at Salisbury and continues its final journey to the sea at Christchurch.

Its name, literally 'winding water', is believed to derive from the Celtic words *nydd*, to twist or to wind, and *dwr* meaning water. The Saxons called it 'Naedre', meaning a serpent. Both aptly describe a waterway whose meandering course adds so much to the variety of the landscape through which it passes.

Beloved of fishermen, walkers and environmentalists, the Nadder Valley has not suffered from an over-exposure to tourism. Although possessing magnificent country houses and vistas of great beauty, its charm lies in the secretive bends of the river and its rich diversity of scenery. Woods, fields, narrow waterways and gently undulating hills – these are the backcloth to the hamlets and twisting country lanes that so bewilder the explorer.

This book looks at the villages that have formed within its watershed. In photographs largely dating from the beginning of the twentieth century, it documents and contrasts with a rural society now largely transformed. It should be pointed out that the comparatively small number of photographs depicting some villages is due to the scarcity of available material rather than any attempt to devalue their importance. Similarly the relatively short section on Wilton does not reflect its true economic and social influence on the valley; this has already been depicted admirably in Chris Rousell's *Wilton Through Time*. I have merely tried to 'fill out' a little the picture he has presented.

As for my personal reflections, may I leave you with the following:

Firstly, why has the vitality been sapped from so many village institutions – the WI, the Young Wives' Club, Girl Guides, Cubs and Scouts, the cricket team, and many others?

Secondly, are we going to regret the fact that much of our rural light industry has been replaced by private residences? In our case, at Tisbury, this includes the saw mills, the coal yard, and animal feed and agricultural machinery units. Parmiters, manufacturers of agricultural machinery, has been the last and largest to fall.

Finally, how will we establish a new social cohesion when all the indigenous families (whose children can no longer afford to live there), as well as pubs, shops, schools, post offices and other social meeting places have disappeared?

My thanks for invaluable assistance must go to the many inhabitants of the Nadder Valley and beyond who have preserved and kindly loaned the photographs shown here. This includes the various branches of the WI, which initiated a village scrapbook competition in the 1950s and thereby preserved so much that would otherwise have been lost. The same must be said of those who created the Archive Rooms at Tisbury and Hindon. Their efforts have also preserved much of historical value and provided centres of study for those who wish to learn more about the Nadder Valley. Neither must I forget the original photographers, many anonymous, whose efforts in the past have provided these insights. Most of all I should like to express my gratitude to my wife, Sheila, for her encouragement; to the late Rex Galpin, who spent many hours reproducing the old pictures in this book; and my son in law Michael Gould for his photographic expertise in producing the modern ones.

<div align="right">Rex Sawyer</div>

Any profits from this book will go the work of the Trussell Trust, Salisbury.

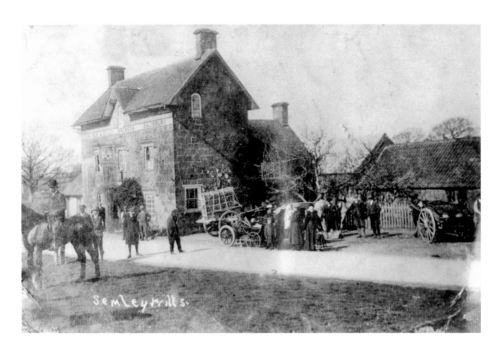

Semley Mills.

The Benett Arms, Semley

A traditional country pub lying close to the village church and what must be one of the largest village greens in Wiltshire. It takes its name from local landowners the Benett family, who lived nearby in Pythouse. The earlier picture shows the pub as a commercial centre as well as a hostelry, whereas today modern transport enables commercial activity to be concentrated in Salisbury and Shaftesbury.

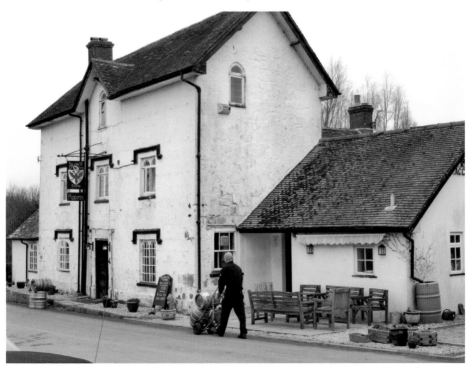

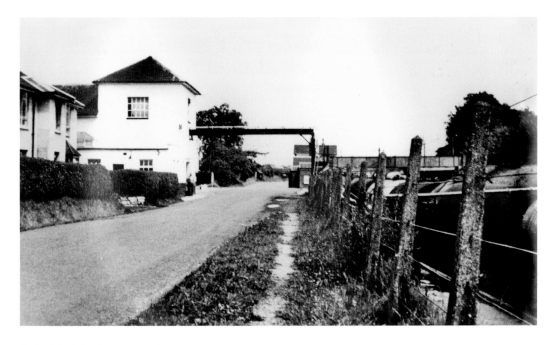

United Dairies Depot, Semley

The United Dairies depot and manager's house at Semley station, between the wars. Also visible is the latest state-of-the-art milk pipeline, which linked directly to specially designed tankers on the railway waiting to deliver milk to the London market. With the closure of the Southern Railway station in the mid-1960s Semley's industrial life diminished.

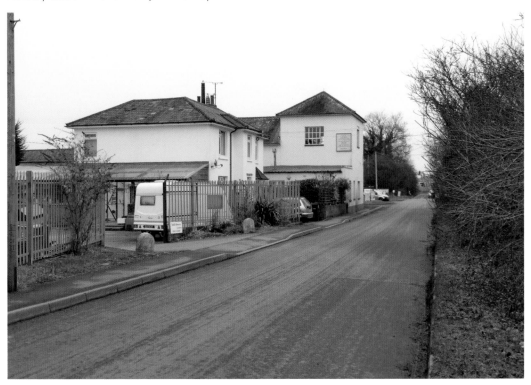

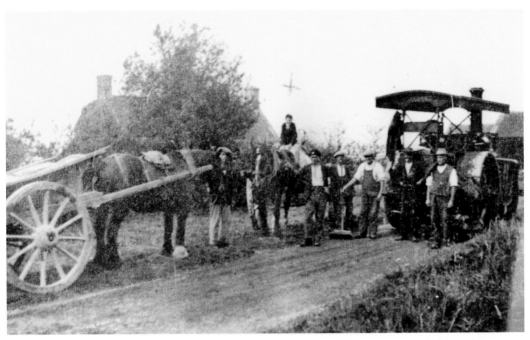

Semley Common

Attempts to develop the common land around Semley have always been fiercely resisted. Until the mid-twentieth century there were gates across the village lanes to prevent animals from straying. Increasing traffic led to their removal and animals no longer graze on the unfenced areas.

In the church, however, a beautiful new window was added to the Lady Chapel in remembrance of a local girl, WPC Yvonne Fletcher, who was shot and killed in the Libyan Embassy siege in London on 17 April 1984.

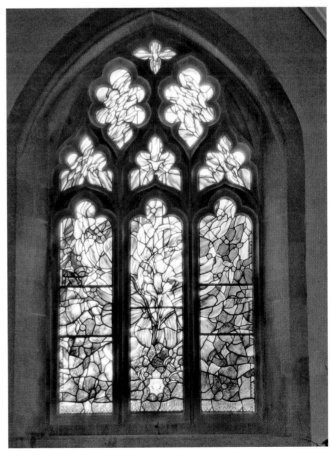

Semley Forge
William Sully, who died in 1965, was the skilled and respected blacksmith shown here at Semley. From his forge overlooking the village green he produced wrought ironwork that can still be seen around the village. Today the forge remains fully active.

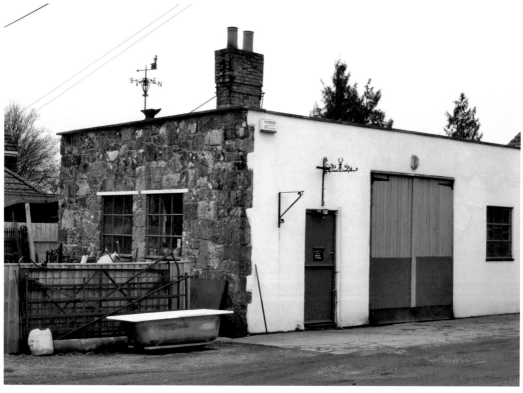

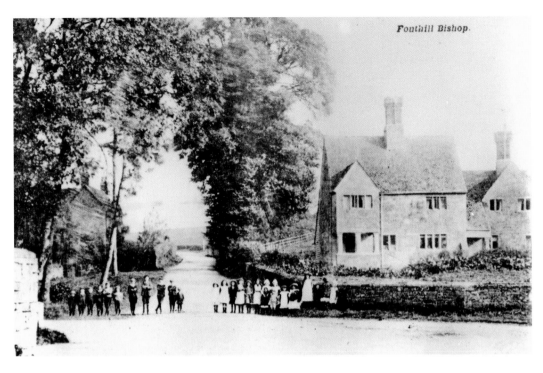

Fonthill Bishop.

Fonthill Bishop at the Beginning of the Last Century
The school children are shown standing across the Barford to Hindon road. Today the road has developed from a small country lane to the busy B3089 and there is far too much traffic for such an event to be contemplated.

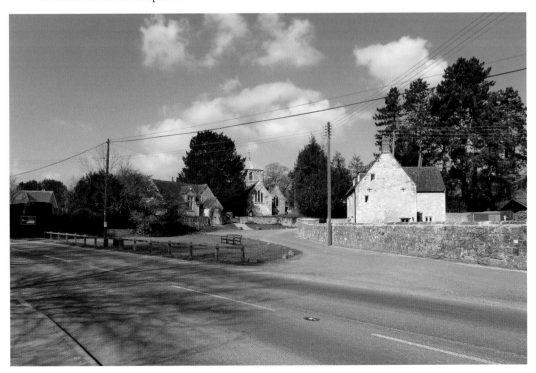

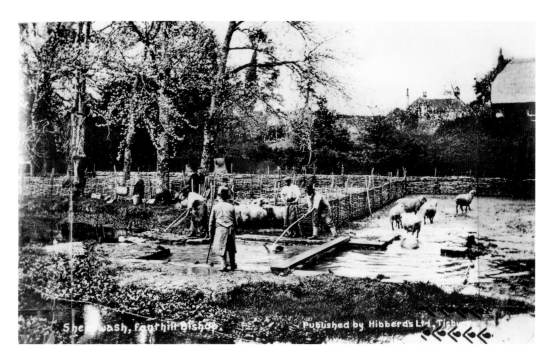

The Sheepwash at Fonthill Bishop

The stream lying adjacent to the vicarage was a convenient spot to bring down the sheep from Fonthill Downs for watering and checking. Today it remains a peaceful haven beside the busy road.

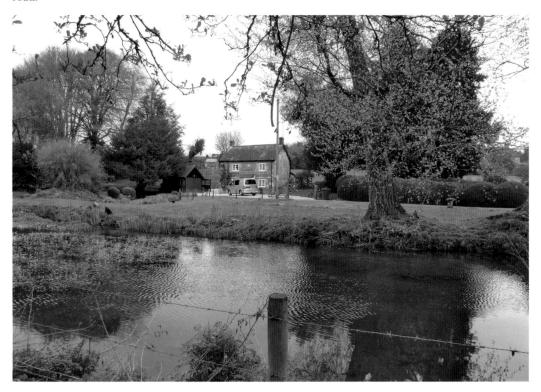

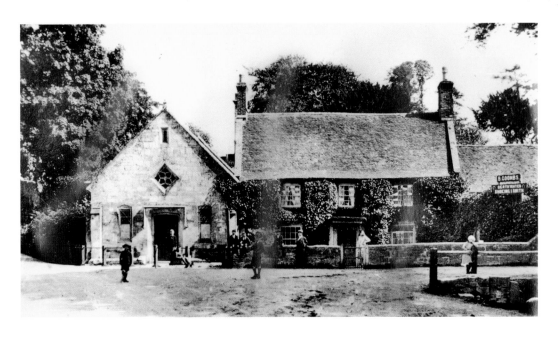

Hindon Village Hall

Directly ahead is the present-day village hall, which has a chequered history. From 1867 to 1889 it became the Petty Sessions hall. In 1922 it was bought and given to the village as a reading room for men, many of whom were unemployed. The prominent building in the centre was used from around 1790 as a 'mad house'. It later became the police station, where the superintendent also lived, while two constables occupied adjacent cottages.

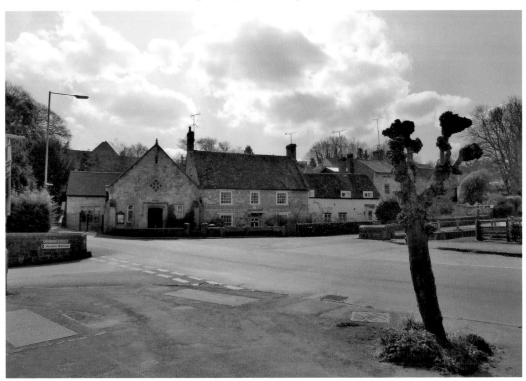

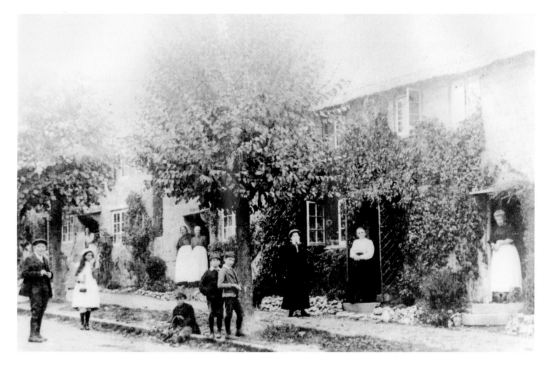

The Upper High Street, Hindon, 1909
The local inhabitants, dressed in their best, are obviously staged for the benefit of the photographer! The trees were planted in 1863 by Michael Shaw-Stewart to commemorate the wedding of the Prince of Wales (later Edward VII). They have been pollarded in the recent picture and the war memorial is seen in its present position by the church.

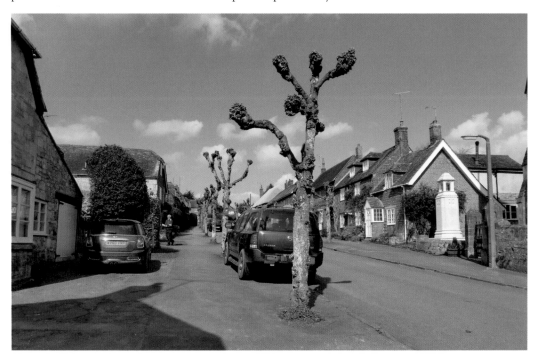

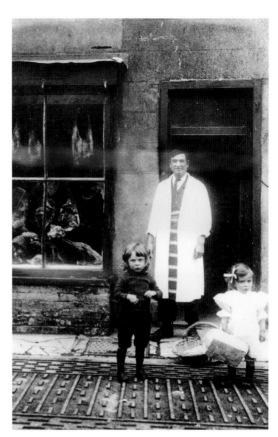

The Hindon Butcher
James Knowles, the local butcher, is shown outside his shop with his children, Len and Cathie, in 1913. You can see the weighplate in the foreground. The shop is now a private residence known as Queen's Head Cottage.

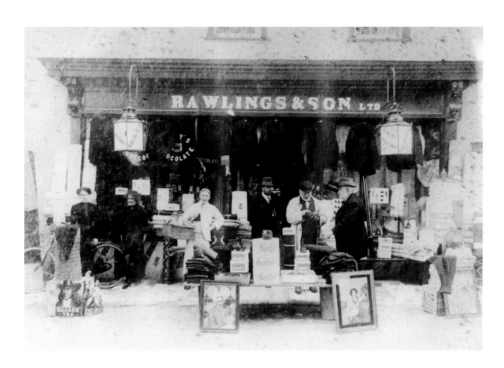

Rawlings Stores, Hindon

Described by an assistant as 'one of the best drapers for miles round, but you ought to have seen the beautiful tea services he broke up when he was angry', Reg Rawlinson's drapery and general store, previously the Swan Inn, is shown before the Second World War. Today the premises are used by an artist in wood.

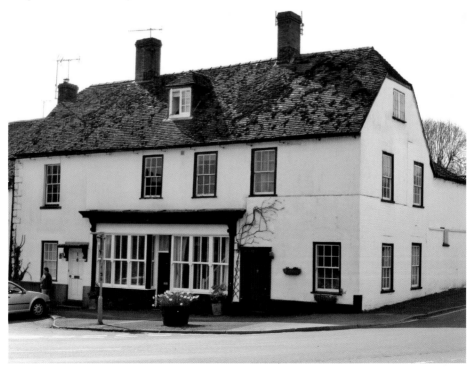

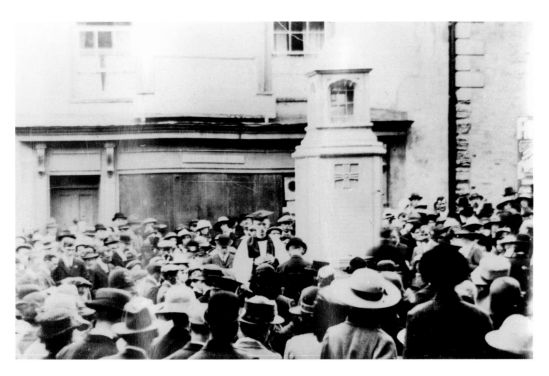

Unveiling the War Memorial in Hindon High Street
Hugh Morrison, MP and local landowner, performed the ceremony on 17 October 1919. In 1943 the memorial was partly demolished by a runaway tank and later rebuilt close to the church, a former chapel-of-ease, where it remains today.

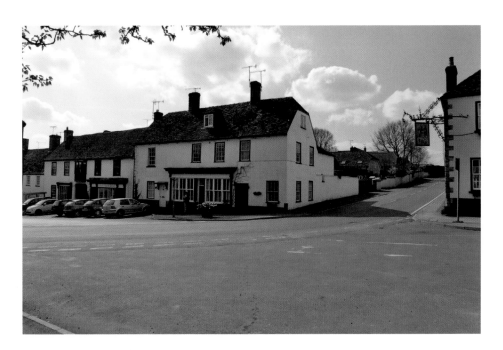

The Hindon Crossroads

You are standing at a point where the lower High Street meets the B3089 road from Barford St Martin. The Angel Inn, once one of fourteen in the medieval town, is situated to the right. This would have been a prominent place for trading. The man in the lower picture was John Beckett, the basket maker, shown holding the horse's head.

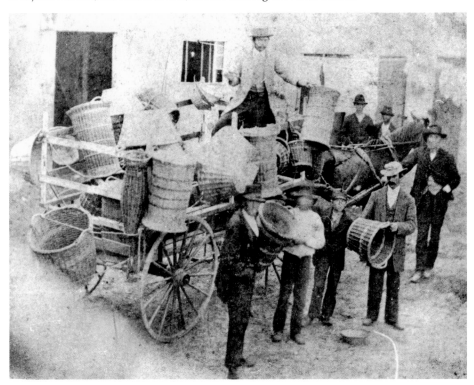

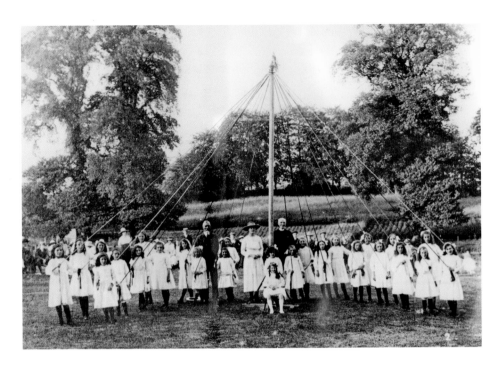

Hindon School

With the construction of the Salisbury to Yeovil railway line in 1859, Hindon's nearest railway station was 3 miles away at Tisbury, and it dwindled into the small village it is now. Trade has diminished but the school, dating from 1854, continues to flourish, supplemented by children from East Knowle.

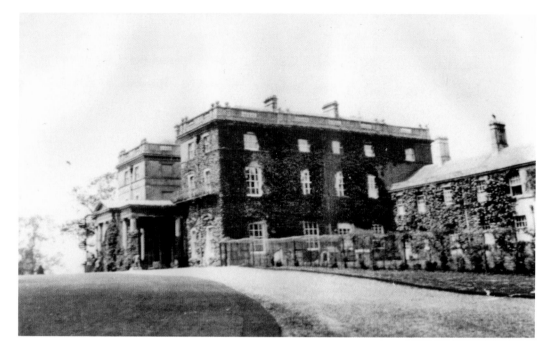

The Ferne Estate

Lying below the chalk downland and the 700-foot-high Win Green, is the plantation of Ferne. From 1563 until the end of the nineteenth century it was the home of the Grove family, owners of a large amount of land in the area and a fine townhouse at Shaftesbury. The family is still commemorated in the area by the Grove Arms at Ludwell, where their insignia (*inset*) can be seen in the main bar.

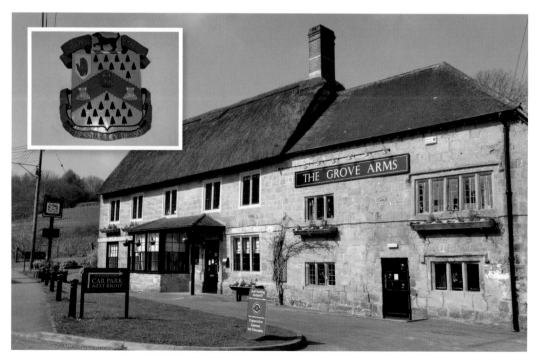

The Carpenter's Arms, Donhead St Mary

Situated in Britmore Lane, the Carpenters Arms, like so many of our rural pubs, has now become a private residence. Built in the eighteenth century, it ceased to trade in 1953 but retains much of its original character as a detached cottage.

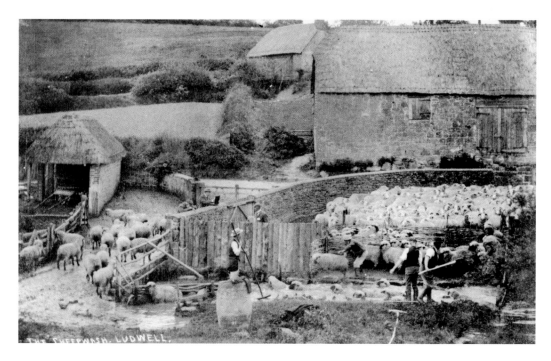

The Sheepwash at Ludwell

For countless centuries shepherds have been tending their sheep on the uplands of Wiltshire. Here, at Ludwell, we see another example of their care before new techniques in arable farming and the use of artificial fertilisers to replace sheep dung led to their decline and the peaceful meadow we see below.

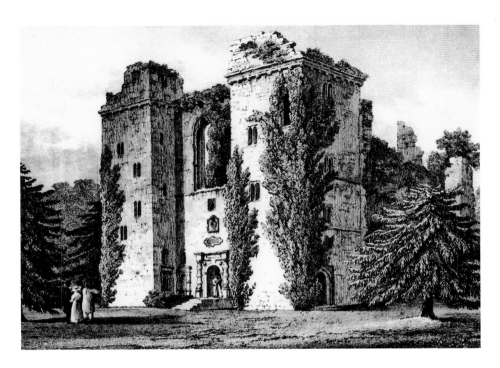

The Wardour Castles

The ruins of old Wardour Castle, unusually hexagonal in shape, are well hidden by the surrounding woodland. The Arundell family came into possession in 1547 and resided there until the castle was shelled into submission during the Civil War. It was not until 1776 that the family had recovered its fortunes sufficiently to build a new one – reputedly the largest Georgian house in Wiltshire. It includes a most exquisite Roman Catholic chapel. Today the mansion is split into private apartments.

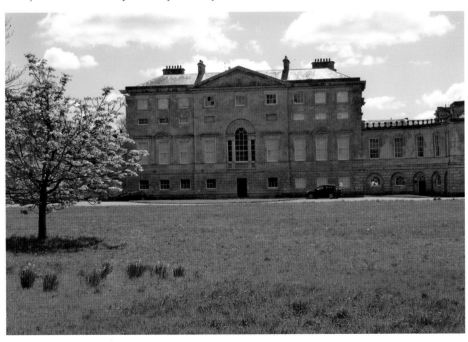

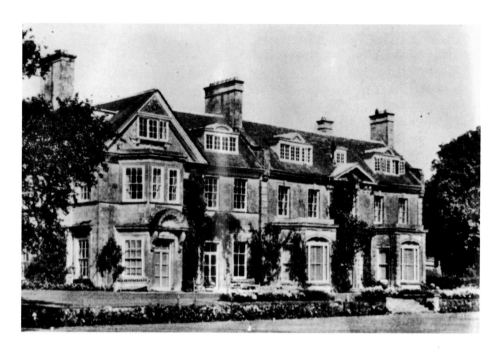

Donhead House, Donhead St Andrew

Donhead House was previously the rectory. The last rector to live there was Horace Chapman, who converted to Catholicism and enlarged the house to its present size in 1895. For a while it became the home of Sir Anthony Eden, the post-Churchillian prime minister, after his retirement. Across the lane lies St Andrews Church, thought to be of Saxon origin and, later, part of the estates of the abbess of Shaftesbury.

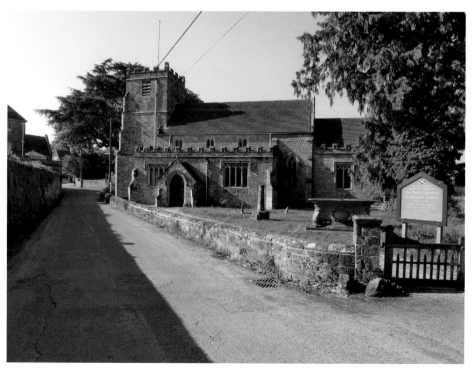

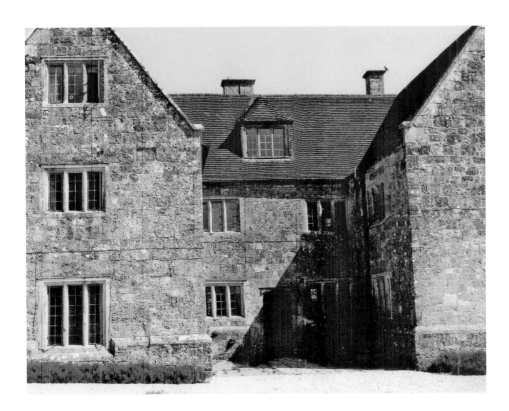

Hook Manor, Donhead St Andrew

The manor was the home of Ann Arundell who, with her husband the 2nd Lord Baltimore, founded the American colony of Maryland in 1633. There are images of the first ships to sail there, the *Ark* and the *Dove*, engraved in the ceiling of the living room. The link continues. Members of the Maryland Militia are shown outside Hook Manor during their visit in May 1996.

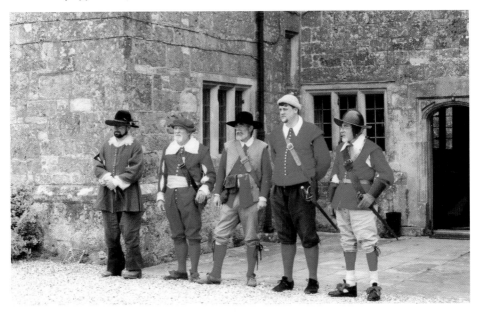

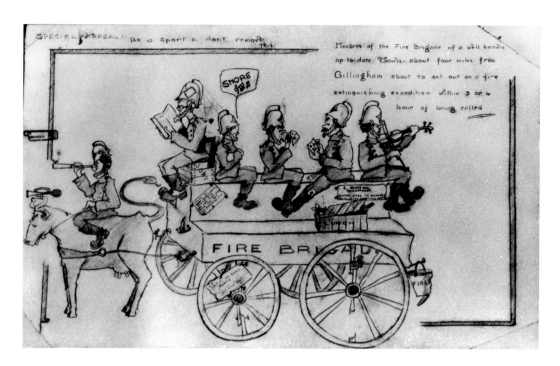

Whitesands Cross

This cartoon depicts Shaftesbury fire brigade arriving four hours after being called to a fire at Whitesands Cross, Donhead St Andrews, in the 1920s. The artist was Mr Wilmott, the Shaftesbury chimney sweep. Today the junction is far busier, being part of the A30 Salisbury to Shaftesbury section.

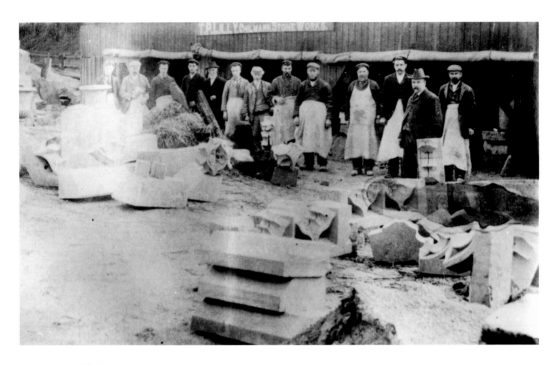

Tom Lilly's Stone Yard

Tisbury was riddled with stone quarries in the past. The stoneworks shown were where the stone came to be faced and made ready for onward transportation. However, trade further afield was always restricted by the high cost of moving stone. With the coming of the railway in 1859 costs were reduced considerably and trade increased.

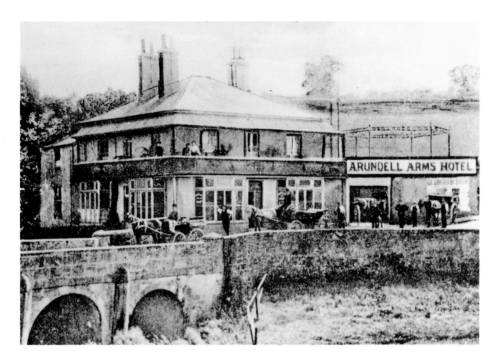

The Arundell Arms, Tisbury

This hostelry was one of two built following the construction of the railway in 1859. The picture would have been taken around 1907; the amount of traffic visiting the stables indicates its popularity at that time. The beautiful metal balustrade shown in the picture was taken down when the pub closed but has been restored by the present owner, as shown in the bottom picture.

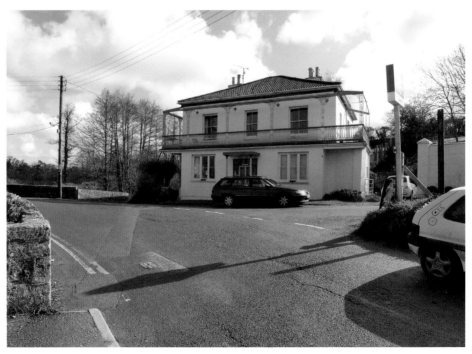

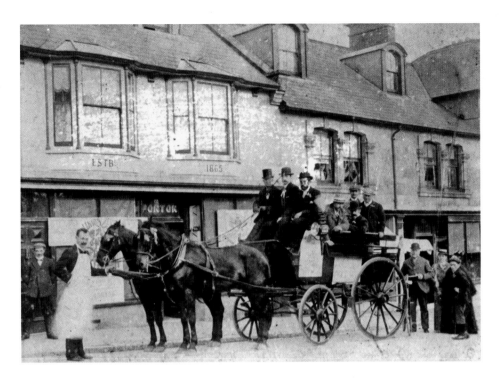

Election Day, Tisbury Square, 1900
The scene is Tisbury Square, probably in 1900 when J. A. Morrison of Fonthill Park was returned as Member of Parliament. George Ponton, a saddler, is seen here holding the horse's head outside his shop, which is now a hairdresser's. Today the square remains the hub of Tisbury activity, although the method of transport has changed considerably!

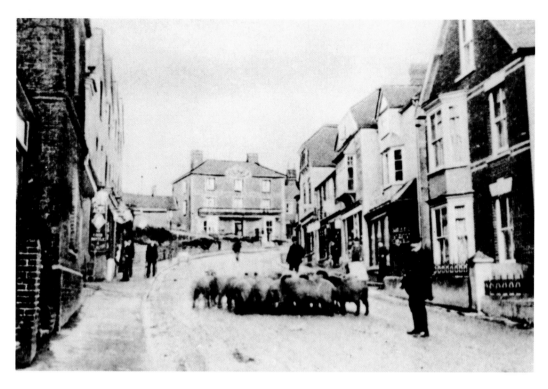

Tisbury High Street, Early Twentieth Century

It has been a long time since animals could be moved freely through Tisbury High Street! The sheep were probably going to one of the three slaughterhouses found here during the first half of the twentieth century. Today it is cars and commercial vehicles that impede progress. The shops and the Benett Arms, shown above the sheep, look surprisingly unchanged today.

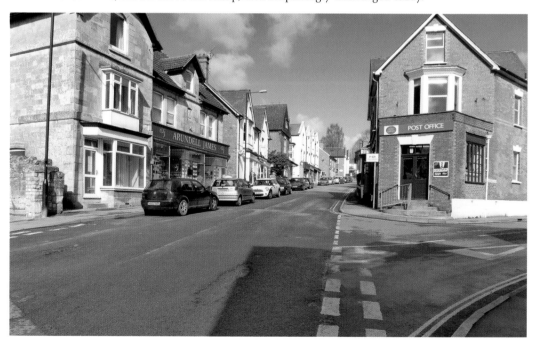

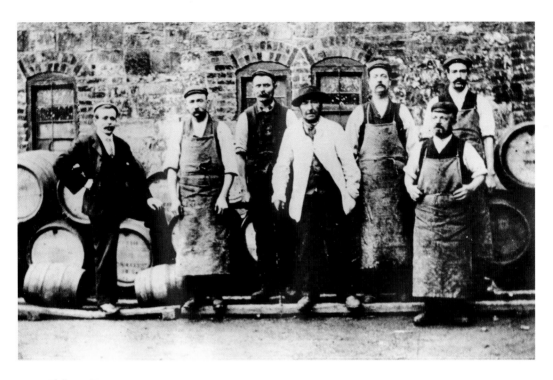

Tisbury Brewery

Although the building has served a variety of purposes since its construction in the mid-1880s, it has been used primarily for the brewing of beer. In the top picture, for example, we see the workers of Mr F. Styring, who ran it in the 1880s. In more recent times, however, it has been converted into apartments.

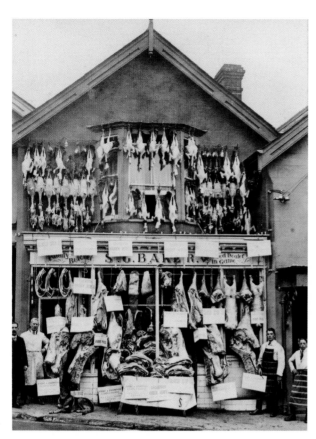

Christmas Preparations at Gil Baker's Butcher's Shop, Tisbury, 1925
Gil Baker was the second generation of his family to run the High Street butcher's shop, later followed by his son Toby. Gil, seen to the right in the striped apron, purchased his cattle from Salisbury market; they were then slaughtered in the village. Today the shop is owned by Boots the chemist.

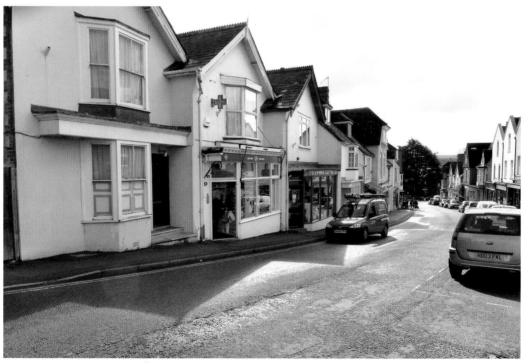

Tisbury Workhouse, Monmouth Hill
Originally built on the site later occupied by the brewery, it was soon deemed inadequate. The new Union Workhouse shown below was built on Monmouth Hill, above the church, in 1868. It was demolished in the 1960s, giving way to a housing estate.

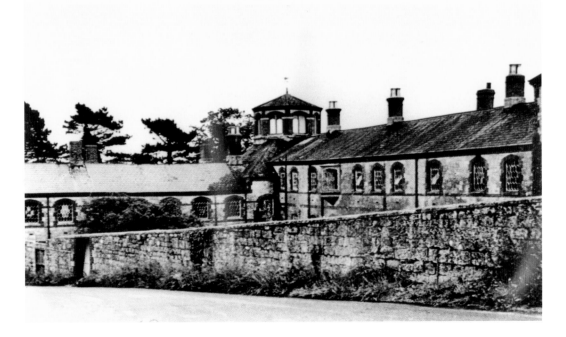

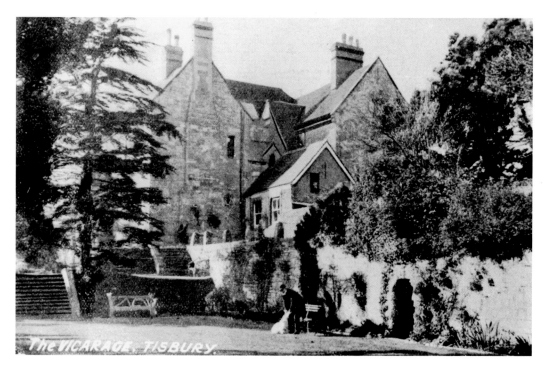

Tisbury Vicarage

The Revd F. E. Hutchinson was vicar of Tisbury from 1858 to 1913. Generous to a fault, he and his wife used their considerable wealth to improve the fabric of the church, the schools and parish life in general. In the top picture Revd Hutchinson is shown outside the massive vicarage that he also built. Today it is split into two privately owned residences.

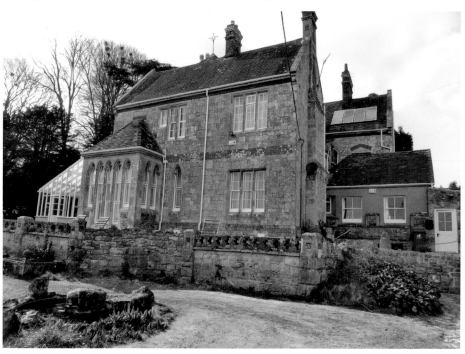

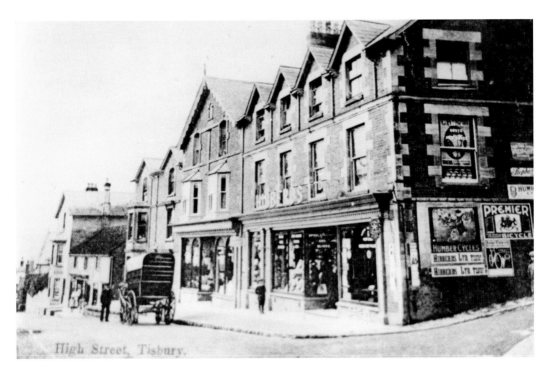

High Street, Tisbury.

Hibberd's Emporium, Tisbury

Elias Hibberd came to Tisbury in 1812, but it was his two sons, Ebenezer and Rowland, who built up the vast business. It was said that anything could be purchased there from a pin to an elephant! Their large premises can still be identified leading up the High Street to the corner of Weavelands.

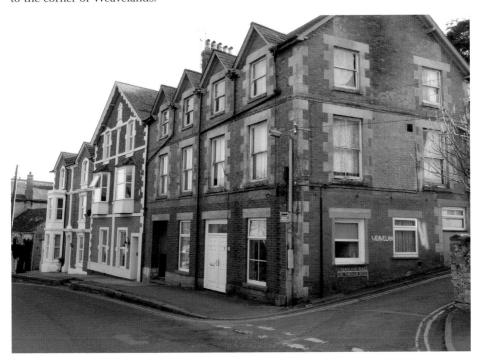

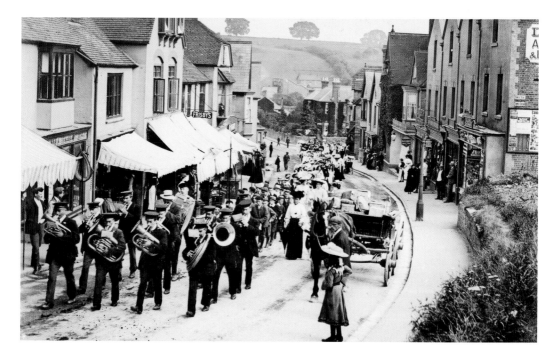

Celebrations at Tisbury

The first picture shows the peace celebrations held on 19 July 1919. Children are heading the pageant up the High Street, accompanied by the village band. A tea party was held at Place Farm, with dancing and games during the evening. An annual carnival continues to be held each September with a procession through the High Street.

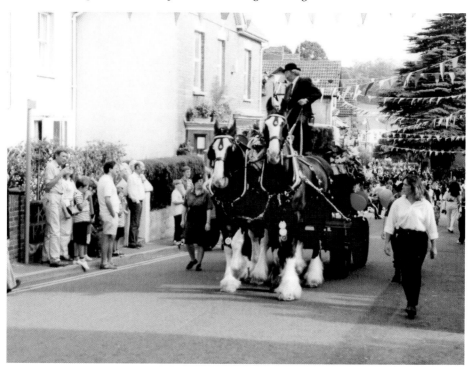

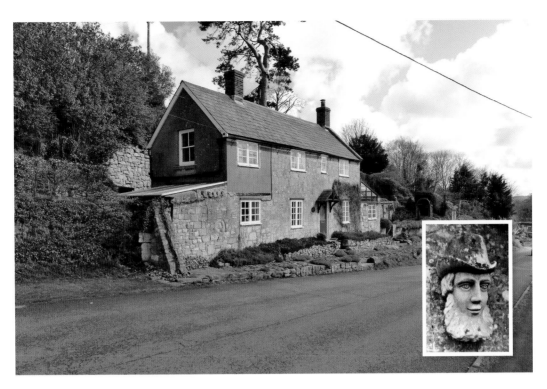

Zion Hill Cottage, Tisbury

Situated halfway up a hill, this cottage was the home of the stonemason James Rixon in the second half of the nineteenth century. In his spare time he loved to carve rather macabre heads, which are said to resemble villagers of the day. Several can be seen among the ivy as well as the one shown inset.

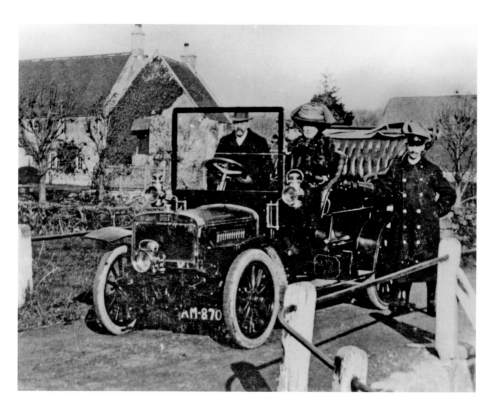

Place Farm, Tisbury

'Mad' Jack Benett, from Pythouse, is shown driving one of the very first cars to be seen in the Nadder Valley. Behind him is Place Farm, built in the fourteenth century as the summer residence of the abbesses of Shaftesbury. Adjacent to the farmhouse is the barn, arguably the largest in England, which was used for the collection of tithes.

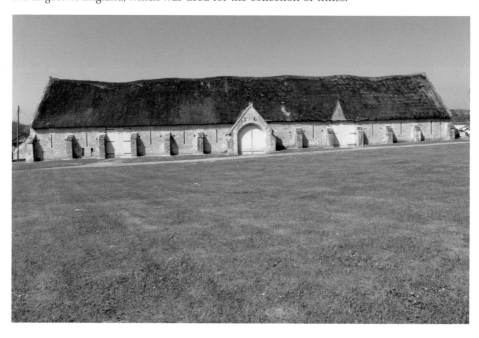

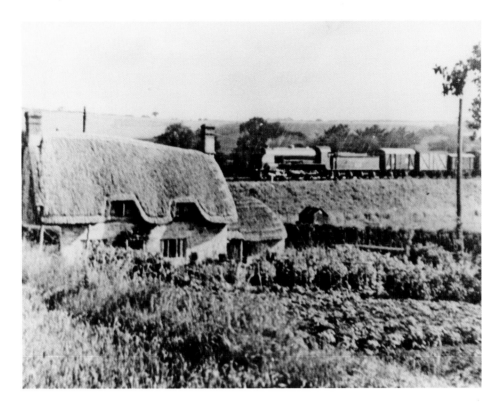

Jay's Cottage, Tisbury

Jay's Cottage, a picturesque residence in Tisbury Row, to the east of the village, nestles below the Southern Railway track from London to the west of England. Steam trains ran until around 1964, when diesel engines took over.

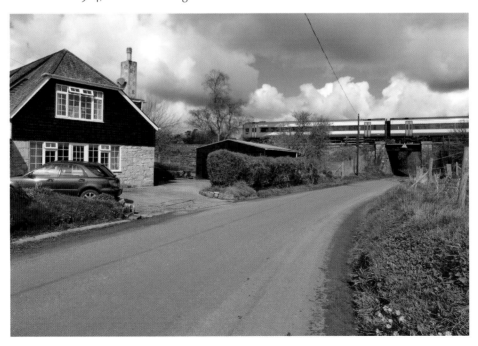

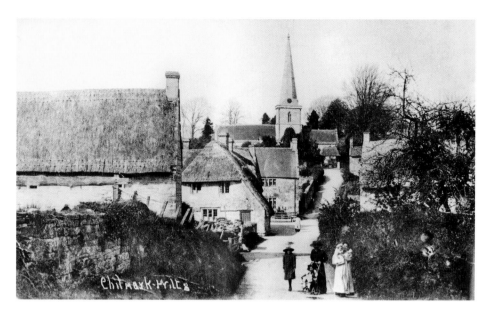

Becketts Lane, Chilmark

You are looking along the length of Becketts Lane in the earlier picture, taken in 1910. The churchyard is entered through the lychgate – a memorial to Emma Lindsell, who was killed when she was thrown from her pony and trap. The church was dedicated to St Margaret of Atioch in the thirteenth century, possibly by returning Crusaders. The handsome spire was added much later, in 1770.

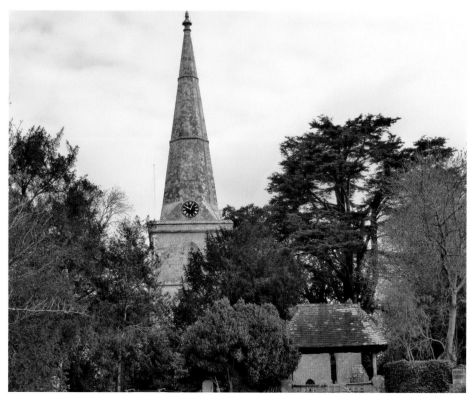

Francis Harding, Chilmark

Near the crossroads lies the cottage of Francis Harding, Chilmark's former carpenter, wheelwright and coffin maker. He was also sexton, undertaker and verger at the church, and he constructed a special trolley for wheeling coffins up the hill to the church.

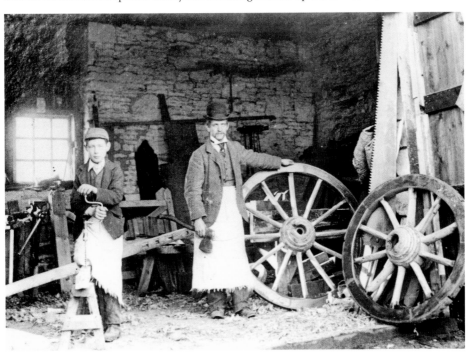

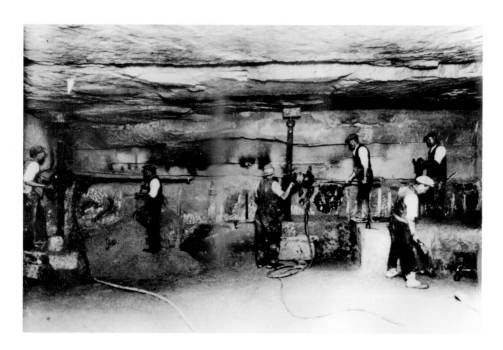

Chilmark Quarry

The earliest evidence of quarrying at Chilmark dates from Roman times. From the vast underground quarry, bigger than a football pitch, came high-quality Portland stone for some of the finest churches and cathedrals in southern England. Although the quarry is no longer in use, smaller quantities of stone are still obtained from an area above ground.

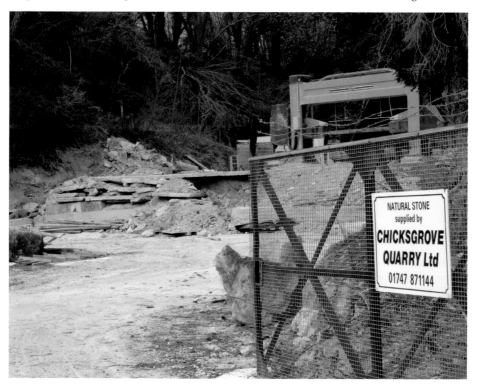

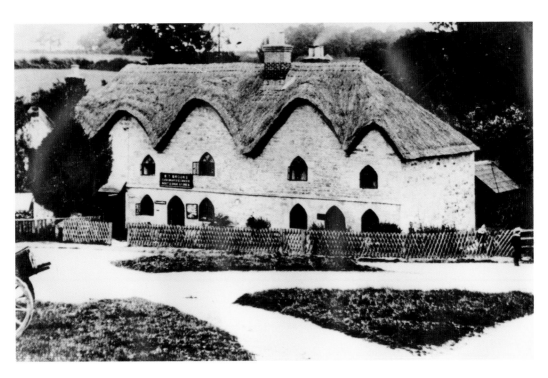

William Thomas Brooks' General Stores, Teffont
The stores lay opposite the Black Horse Inn, as seen in this picture taken in 1905. The sign reads 'Cash Draper & Grocer, Boot & Shoe Stores'. Mr Brooks was formerly a shoemaker at Dinton and his wife, Catherine Jane, ran the post office at Teffont. The cottages remain today as private houses.

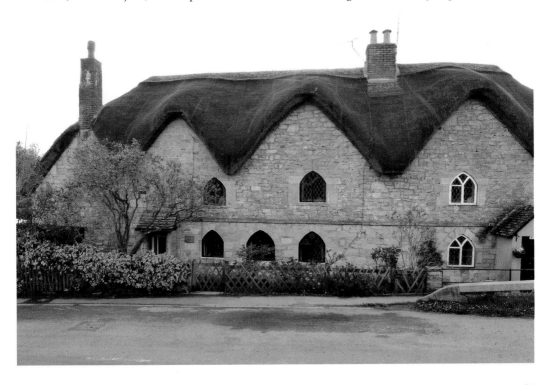

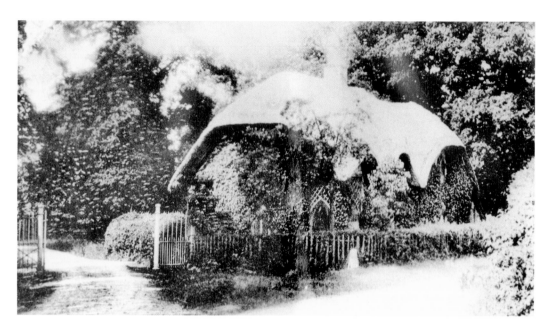

Teffont Lodge

Robert Lee brought up his family in this small lodge belonging to Teffont Manor after he became coachman (later chauffeur) to Charles Maudsley, whose family was celebrated for its achievements in the field of engineering and vehicle manufacture. At that time, before the First World War, the Tisbury road was still gated.

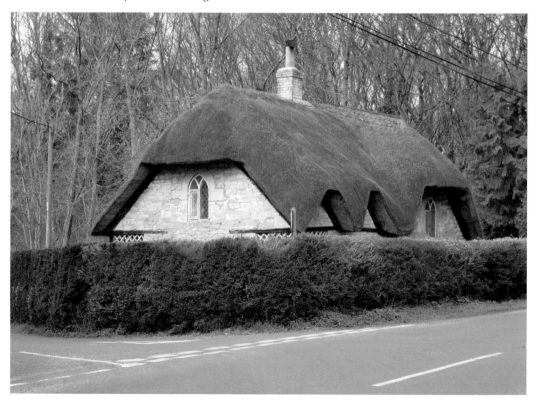

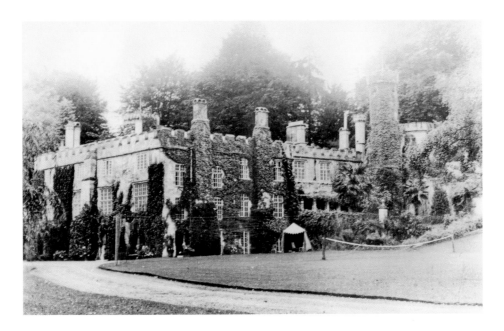

Teffont Manor

The manor house, with its outbuildings and cottages, seems to run into the wooded hillside. Although it is of late Tudor origin, much that we see today in fact dates from the early nineteenth century. During the Second World War important maps pertaining to the Normandy Landings were printed here. After the war it was decided to convert the property into three apartments. The beautiful view from the manor over the Nadder includes the church of St Michael and All Angels, which stands in its grounds.

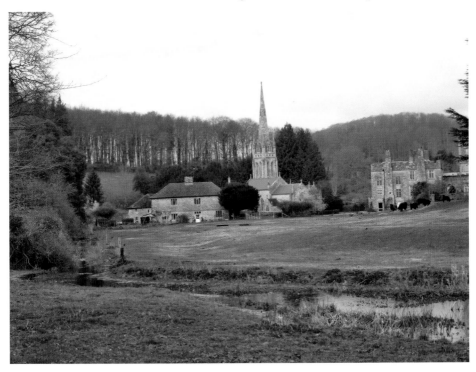

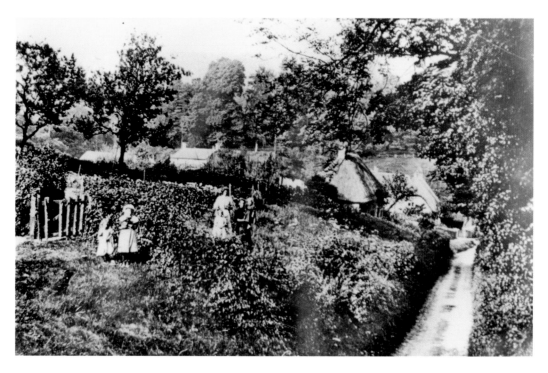

Carters Lane, Teffont Evias

A peaceful pastoral scene in the early 1900s. It is still possible, further down, to see the bricked-up lime kilns once linked to the stone quarry, which lay on the hill above. The cottage below lies along the road to the manor where a roadside stream flows onward to join the Nadder.

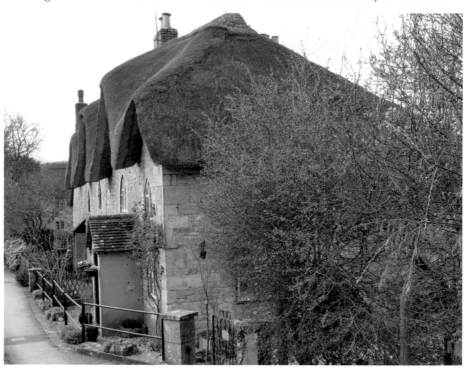

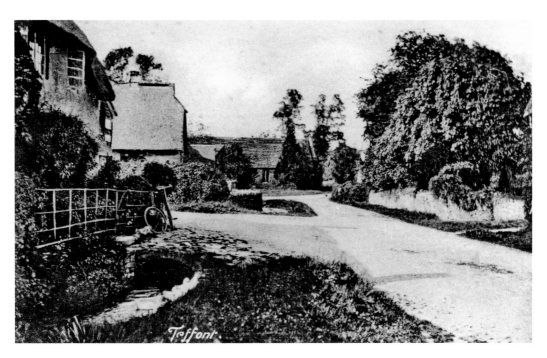

Teffont Magna

Around 1900, when this picture was taken, the busy B3089 looked more like a country lane, with the village school and church lying ahead. The view today reflects the busy thoroughfare. Notice the thatched bus stop on the right.

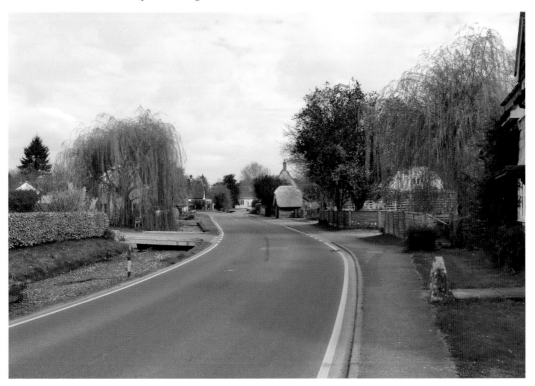

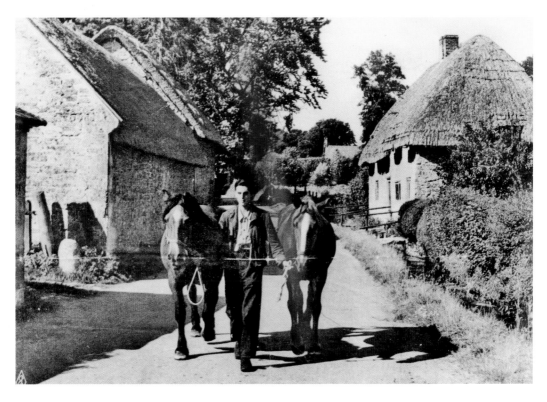

Visiting the Smithy

A pastoral scene at Teffont Evias just after the Second World War. Ralph Stevens is leading the horses to be shod by the Blacksmith, Harry Bull, whose forge lay on the road from Teffont Magna to Teffont Evias. Today the view retains its peaceful air, with the stream passing to the right.

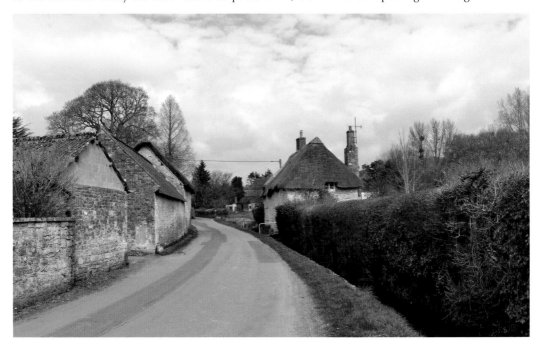

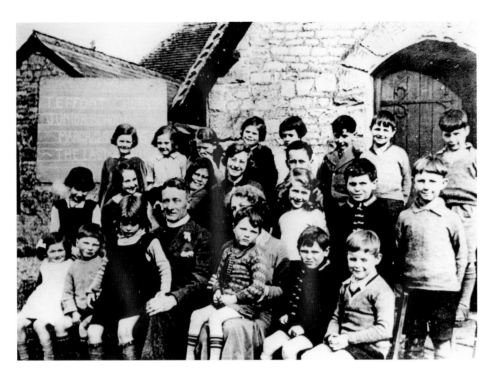

Teffont Church Junior School

The last pupils before the school closed in 1936 are shown here. They then transferred to Dinton Primary School and the new secondary school at Wilton. Now Teffont Village Hall, the former school still has a play area for children.

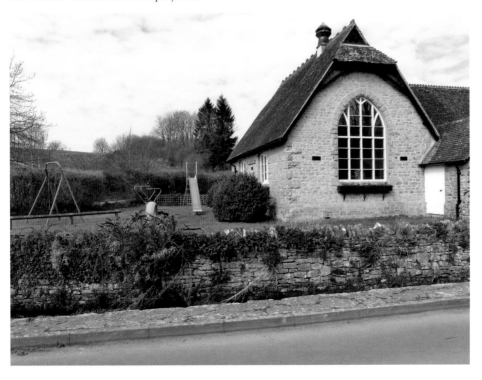

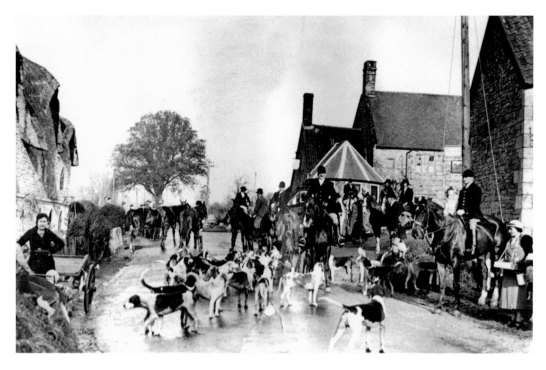

The Black Horse Inn, Teffont Magna
The local hunt is shown outside the inn in the mid-1930s. Lucy Lee is shown selling poppies for Armistice Day. Since the closure of the inn, the premises have become the home of a well-known firm of book publishers.

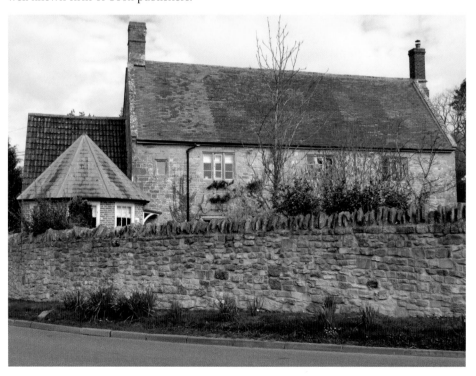

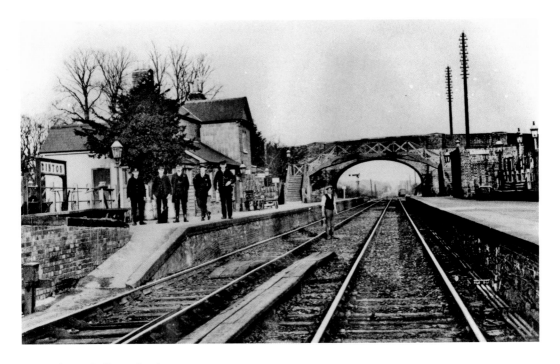

Dinton Railway Station

With the construction of the railway in 1859 Dinton station brought fresh prosperity to the village. Not only was the market enlarged, but farmers from neighbouring parishes arrived to complete their rail journey to Salisbury market. Despite the station's closure in 1966, fresh industrial activity has successfully developed along the line.

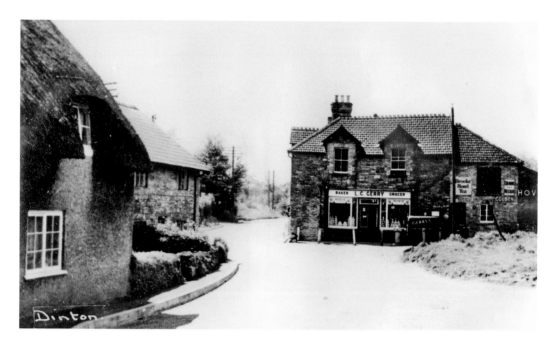

Charles Gerry's Bakery and Stores, Dinton, 1920s
Rebuilt by Lord Pembroke from old farm cottages in 1902, the shop has maintained its central position at the bottom of Snowhill since the nineteenth century. The old post office on the left was demolished in order to straighten the road in the 1950s.

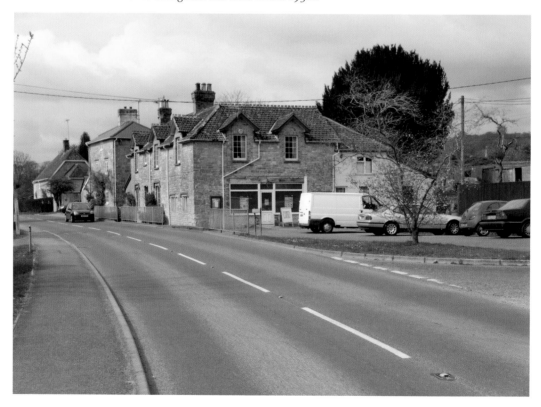

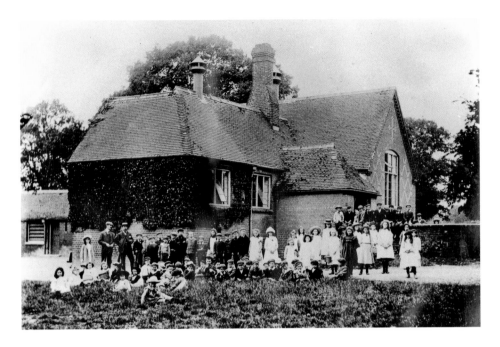

Dinton School

A school existed at Dinton from 1818, when the parish clerk, assisted by three women, did the teaching. It moved to the premises we see today in 1872. The top picture, taken in 1904, shows a healthy attendance. Today the primary school continues to flourish with around ninety-five children attending.

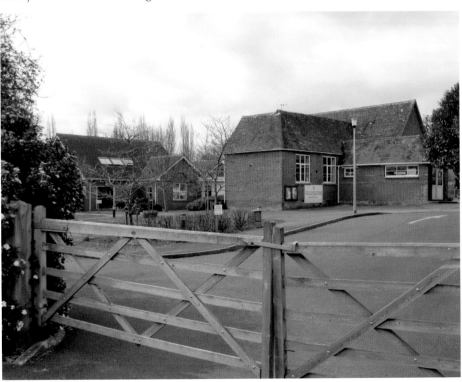

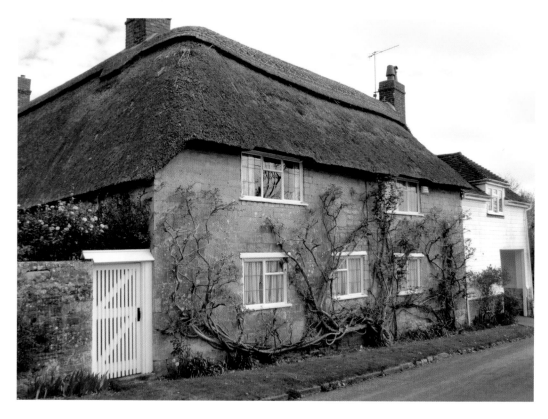

Cotterells, Dinton

For many years Cotterells was the home of Constance Penruddocke always known as 'Miss Penn'. She was much respected for her hospitality to First World War troops stationed in her area, especially Australians, who referred to her as the 'Aussie mother'. Her cottage, situated near the church, remains a handsome residence.

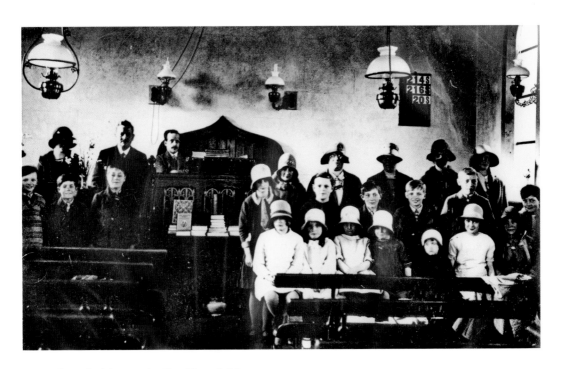

The Primitive Methodist Chapel, Dinton

In 1864 a group of Methodists are recorded in Dinton holding services outside Dinton Church and thereby disrupting its services. It was not until 1895 that they were able to build their own chapel along the Salisbury road. Today it lies adjacent to new residential buildings, awaiting redevelopment.

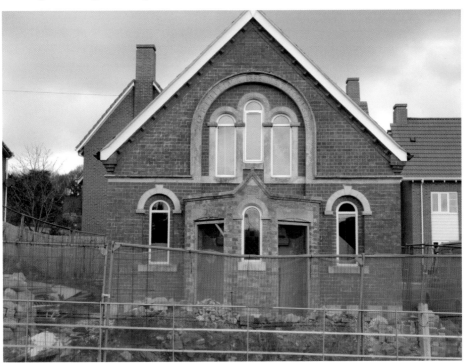

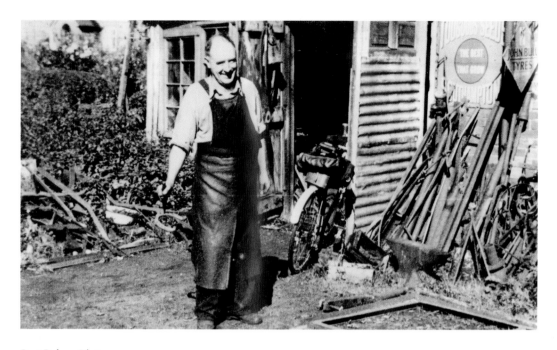

Reg Baker, Dinton

Reg Baker, the Dinton blacksmith, is pictured just after the Second World War. He was the last of a long line of Bakers to ply their trade in the village. His forge, on the corner of Spracklands has now been replaced by new houses and the lovely daffodils that are a feature of Dinton during the spring.

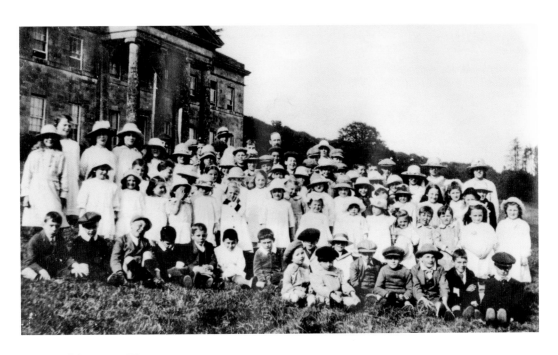

Hyde's House, Dinton

Hyde's House, shown below, has a long and celebrated history. Like Philipps House, it came into the possession of Bertram Philipps and was given by him to the National Trust in 1943. Both lie within Dinton Park, which continues to provide pleasure to groups from anglers to dog-walkers and school parties such as the one shown here in 1920.

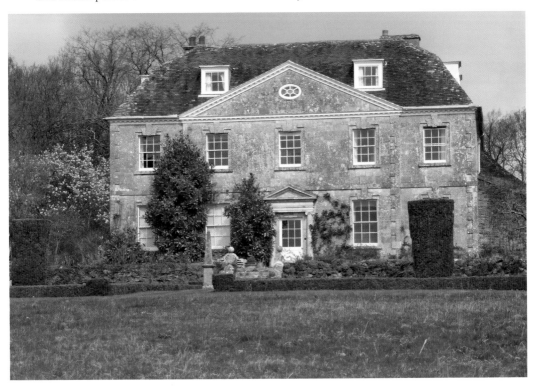

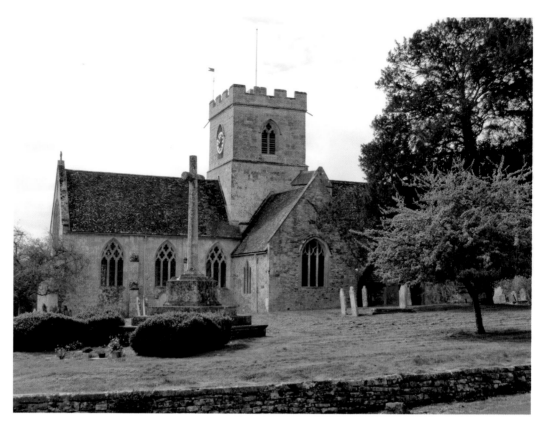

St Mary's Church, Dinton
Like other Nadder Valley churches, St Mary's rose from the ruins of an earlier Saxon church. It was restored during the Victorian period by William Butterfield. Dinton fête days, like the one shown below in around 1904, always commenced with a church service and procession.

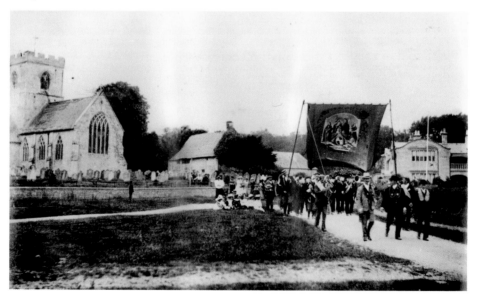

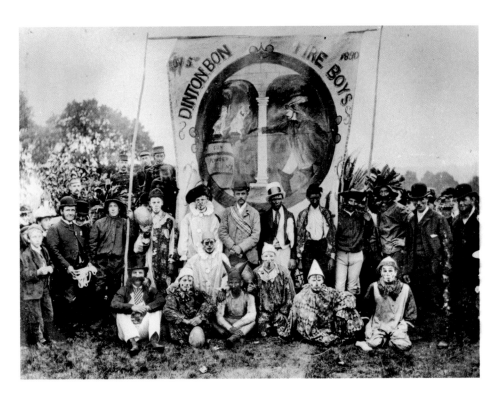

Dinton Bonfire Boys

From as far back as 1890 Dinton has celebrated 5 November with a bonfire in the grounds of Dinton Park. In the past the event often commenced with a torch-lit procession, accompanied by the village band. Philipps House, fringing the park, provides a stately backcloth to the proceedings.

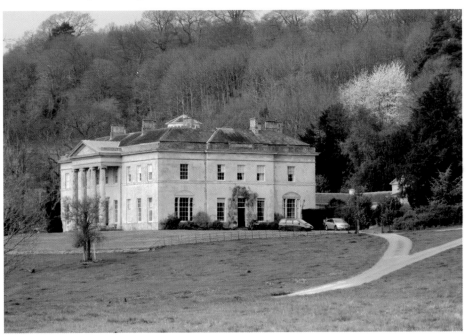

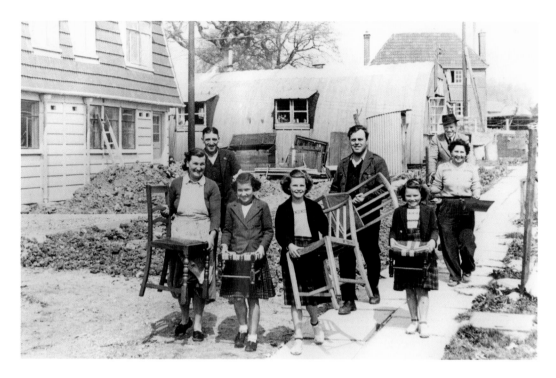

Moving to New Premises, Dinton

After the Second World War, the Nissen huts previously used by American troops provided accommodation for desperate young couples who could not find homes. Nevertheless, a great deal of satisfaction was felt when eventually proper homes became available, hence the happy smiles for the camera.

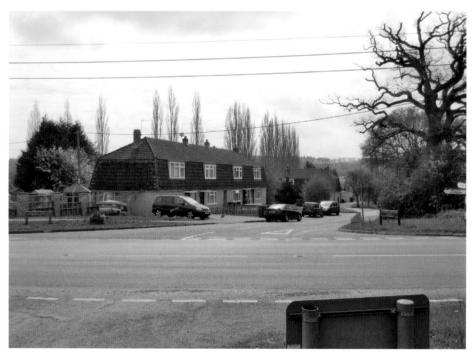

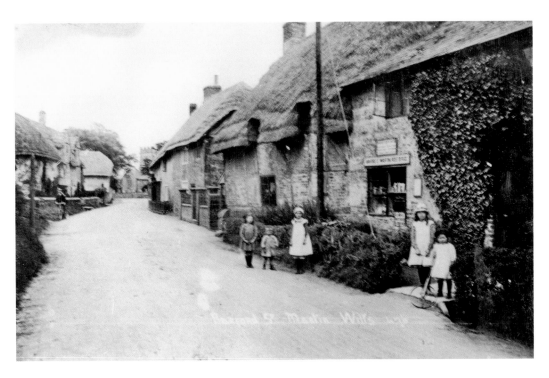

Barford St Martin

The village street of Barford St Martin is shown before the First World War. The main part of the village clusters around the thirteenth-century church, beside which lies an ancient limestone cross. Like so many others, it has lost much if its original shape. The unmade-up road stretching to the cottages would have made the houses difficult to keep clean.

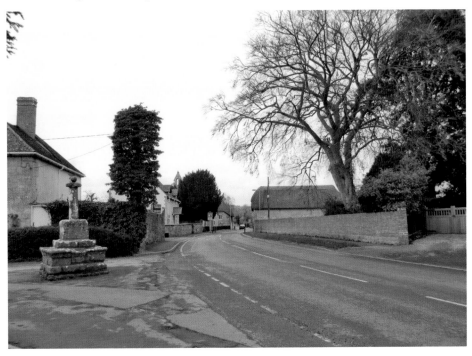

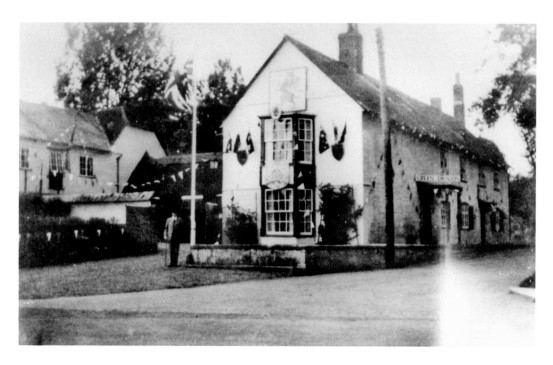

The Barford Inn, Barford St Martin
Previously known as the Green Dragon, the inn harks back to the seventeenth century. The earlier picture shows the inn decorated for King Edward VIII's coronation in 1936, with landlord Ernest Harvey standing outside it.

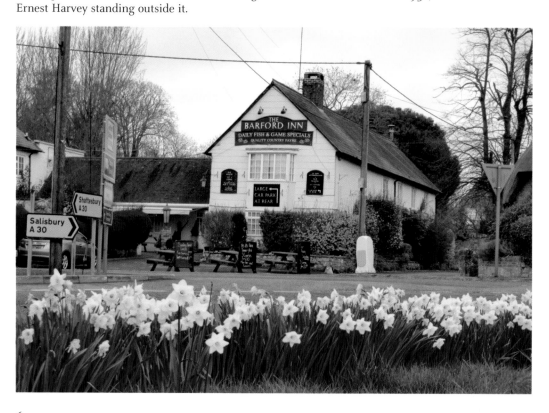

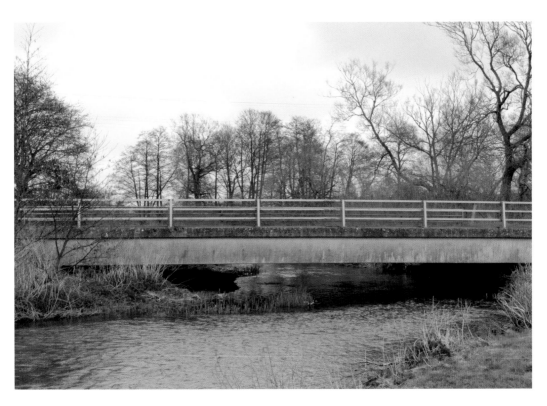

Gall Bridge, Barford St Martin
The bridge straddles the River Nadder, carrying the busy A30 from London to the west. The earlier picture, featuring local resident Jesse Avery, shows the original bridge, which was swept away during a severe storm in 1980. It was replaced with the rather featureless structure we see today.

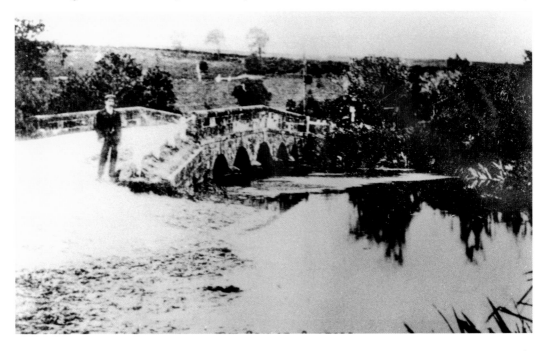

The Maypole Inn, Ansty, 1903

The Maypole Inn was previously called the Arundell Arms. In 1903 the licensee was Walter Gray. Notice that one bicycle (*left*) has pneumatic tyres, while the other has solid ones. Dunlop first made pneumatic tyres successfully in 1890. The inn is now a private residence.

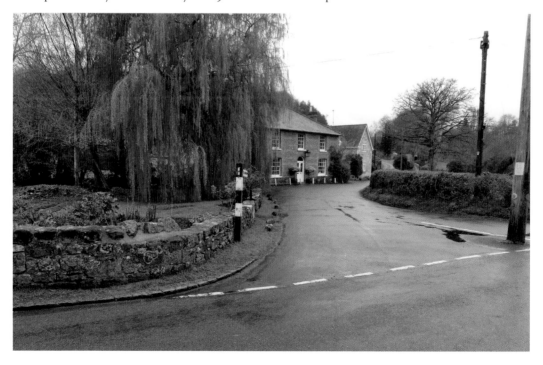

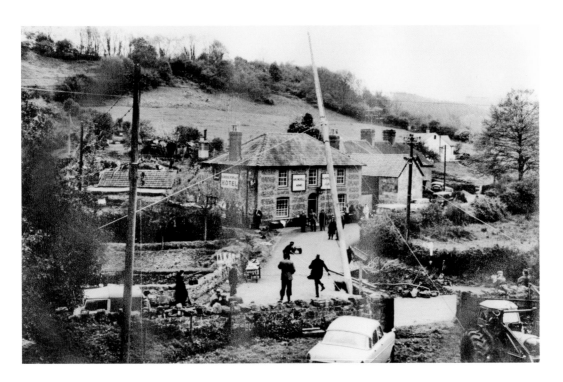

Raising the Maypole, Ansty

A new maypole, shown here, was culled from Wardour Woods and erected in 1962. Its 1982 successor, from Fonthill Park, was snapped off by a storm in 1993, so that the present maypole dates from 1994 and is only half as tall. Dancing around the maypole still continues during each May Day celebration.

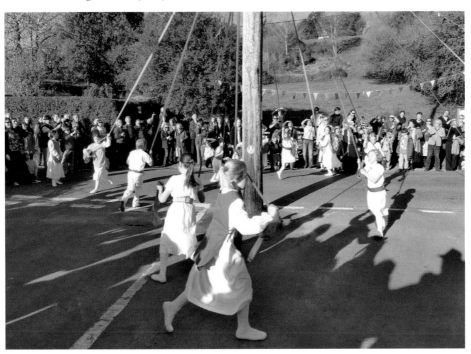

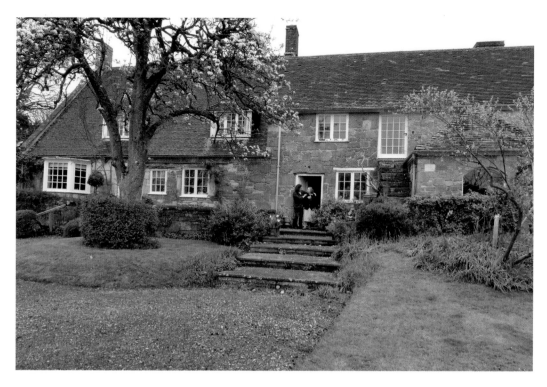

The Village Band at Ansty, Early Twentieth Century
The band included seven members belonging to either the Parsons or Feltham families, who are still represented in the area today. They are performing at the rear of Lower House, where the present owner is shown with her daughter.

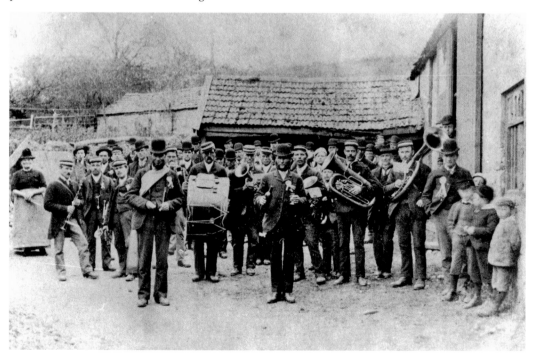

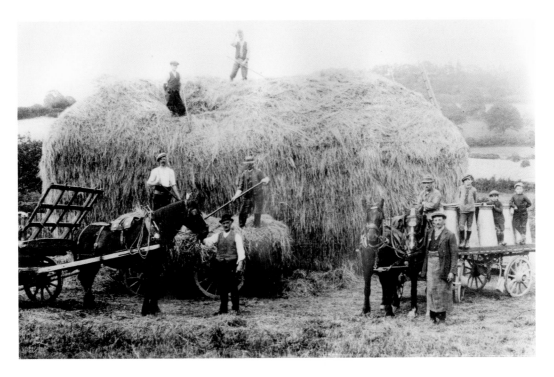

Haymaking at Frog Pond Farm, Ansty

As was customary, almost all of the villagers turned out to help on this occasion in the 1920s. Charles Edgar Lever is seen holding the horse (*left*); Herbie Lever is behind him with the rake. George Parson, the dairy farmer from Lower Farm, stands with his milk cart (*right*). George also made the village supply of cider! The old farmhouse has now been lovingly restored as a private residence.

Ansty House and Workshops, Before 1950

Ansty House lies to the left of the picture. You are looking across the pond to the workshops (notice the clock and bell), which were removed in the early 1950s. Today only the house remains. It was previously the home of Charles Edgar Lever and his brother Walt, who were wheelwrights and carpenters.

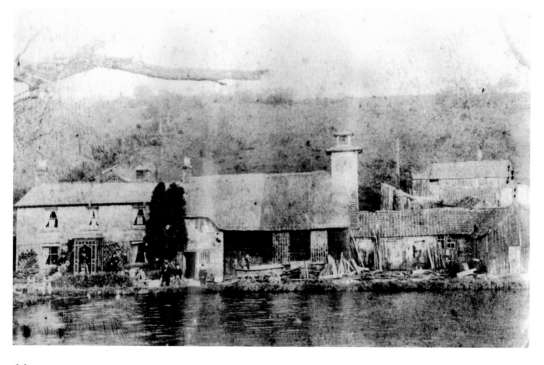

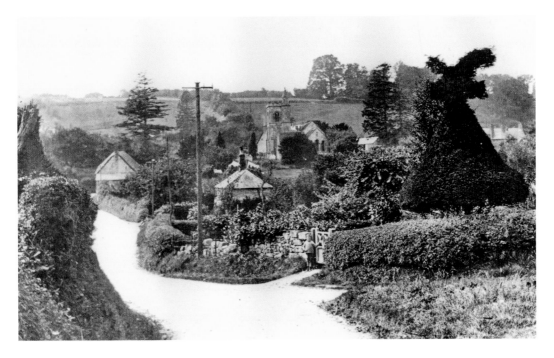

Swallowcliffe

Swallowcliffe is described in the *Anglo-Saxon Chronicle* as 'the cliff of the swallow'. You can see the church of St Peter in the background above. The original church lay among water meadows. By the eighteenth century it had sunk to such a point that frequent flooding 'to a level above the seats sometimes left mud an inch thick on them'. The church we see today, designed by Gilbert Scott, was consecrated in 1843.

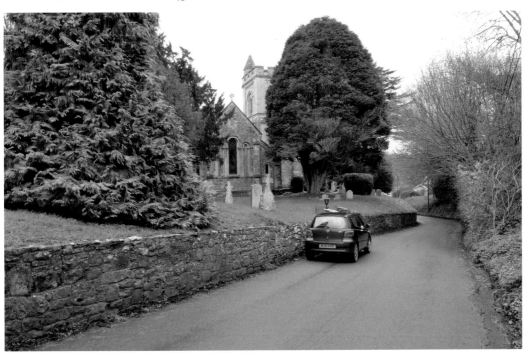

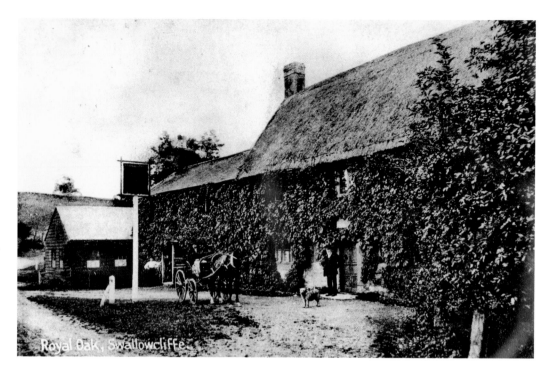

The Royal Oak at Swallowcliffe, 1907
Originally part of an old tannery, one of the chimney stacks still bears the date 1705. The landlord in 1907, William Hansford, is seen standing outside the pub. He was known as a colourful character, and also ran a carpentry and wheelwright business from the workshops at Ansty. Today the pub stands forlornly awaiting an uncertain future.

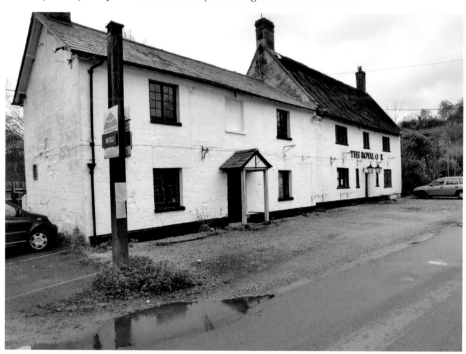

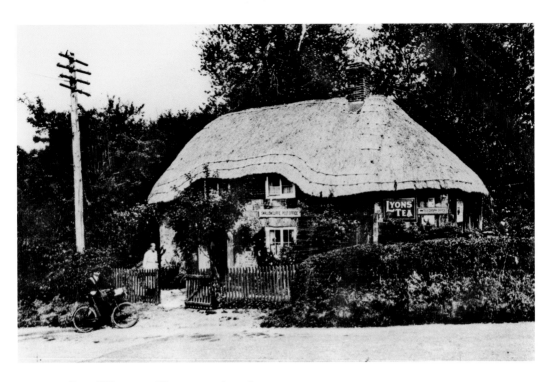

Swallowcliffe Post Office, Around 1928
Ron Hope the postman, with the bicycle, and Mary 'Polly' Burt the postmistress are shown in the picture. She performed that role from the end of the nineteenth century until the closure of the post office, just before the Second World War. Today the village shops and school are all long gone and the post office has been lovingly restored as a private home.

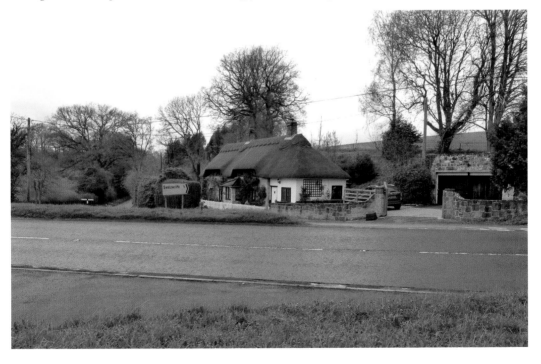

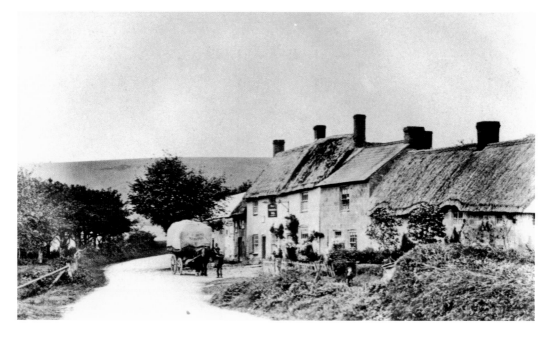

The London Elm Inn, Swallowcliffe

The London Elm, part of a group of cottages, lay along a bend of what is now, astonishingly, the busy A30. The hay cart had travelled from Manston, a village between Shaftesbury and Blandford. The pub closed around 1915 and all that can be seen today of the whole block is a length of stone wall partly hidden by undergrowth.

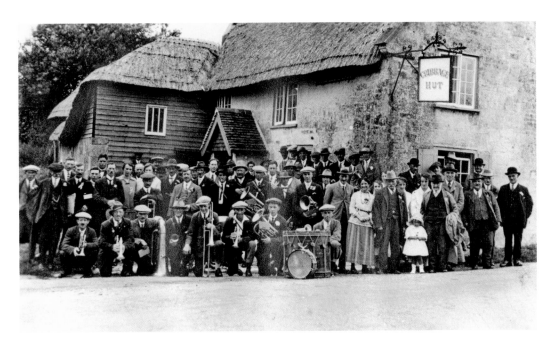

The Cribbage Hut, Sutton Mandeville, Late 1920s

Situated on the A30, it was demolished when the new Cribbage Hut (now shown below as the Lancers) was built further to the east in 1935. The landlord, Albert Trulock Spencer, son of the miller, is shown standing with his wife. With them is Harry Hardiman, licensee of the Compasses at nearby Chisgrove.

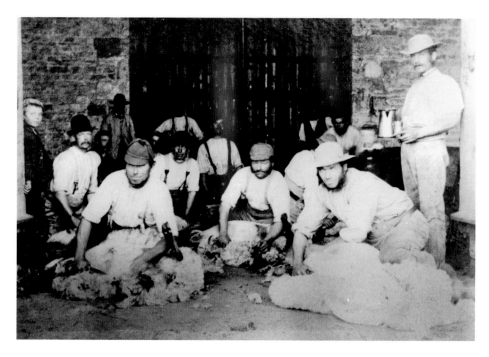

Manor Farm, Sutton Mandeville, Late 1920s
Sheep shearing is taking place in the barn. This picture was taken during the time of the farmer William Miles. *Kelly's Directory* shows him to have been a farmer and miller in the village in the 1880s. His widow, Eliza, was still farming there in the 1930s.

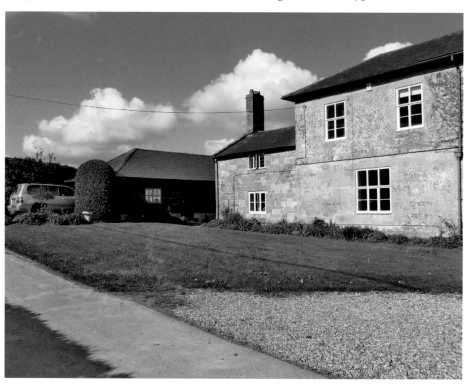

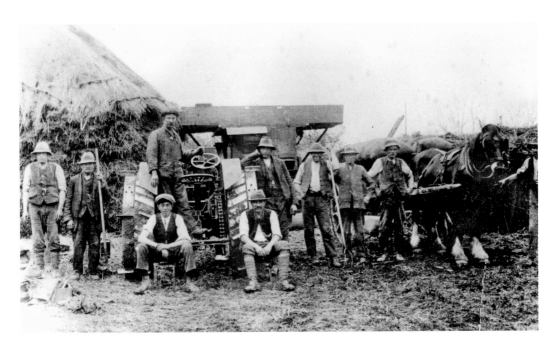

Employees at Manor Farm, May 1923
Due to many changes in agricultural technology and the costs of farm labour, the farm is now being run by the farmer and one part-time helper.

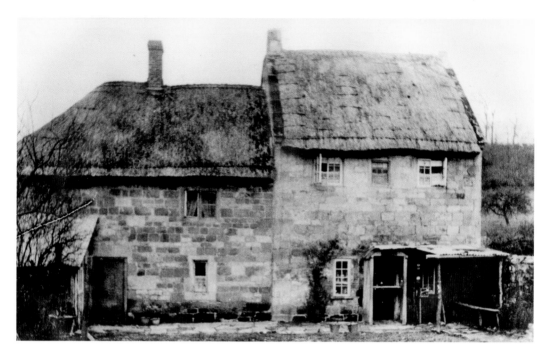

The Sutton Road Sweet Shop
This sweet and tobacco shop in now known as the Stables. Established before the First World War, the shop was in the right-hand part of the house and kept by Alfred, a member of the large Mullins family who lived in the village.

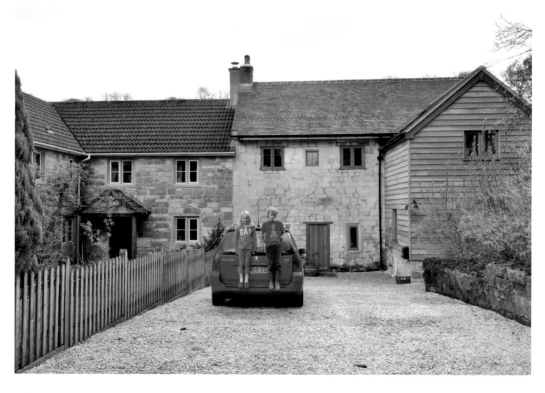

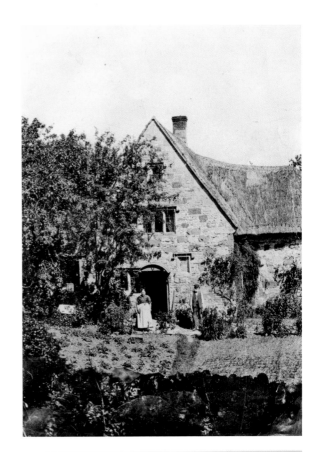

Ivy Cottage, Sutton Mandeville
Now known as Bonds. This picture taken around 1905 shows Margaret and Frank Mullins, smallholders in the village, who brought up their family of fourteen children here – thirteen boys and then a girl, Dorothy. Today Bonds enjoys a quieter existence.

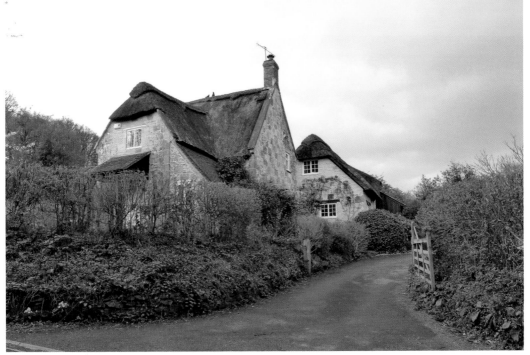

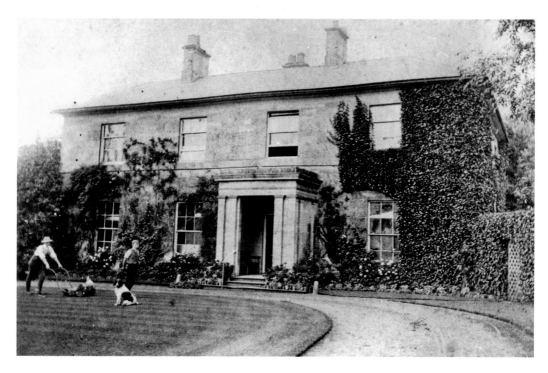

Sutton Mandeville Rectory and School

The stately rectory, now a private residence, was built by the Wyndhams of Dinton Park with a view to one of their younger sons, Revd John Wyndham, succeeding to the living in 1840. Although the village school belwo closed some years ago it also remains as a charming residence.

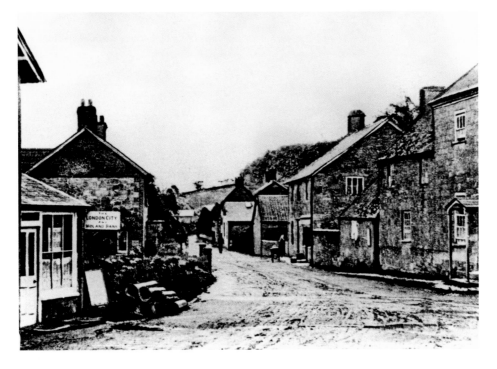

Fovant High Street

Fovant is situated in the middle of a district noted for its ancient earthworks. Many Roman coins have been found in quarries nearby, proving that the quarries are of very great antiquity. During the First World War, when this picture was taken, it was also the centre of a large military training area. The London City and Midland bank in the foreground indicates its commercial importance. In the bottom picture you are looking across the A30 to the now defunct Crosskeys Inn.

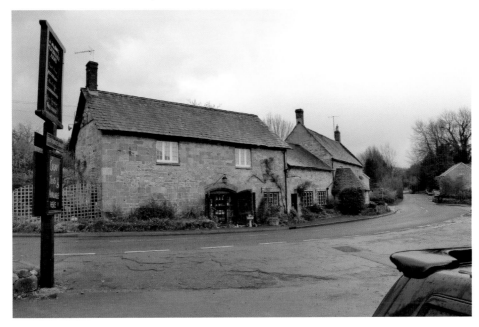

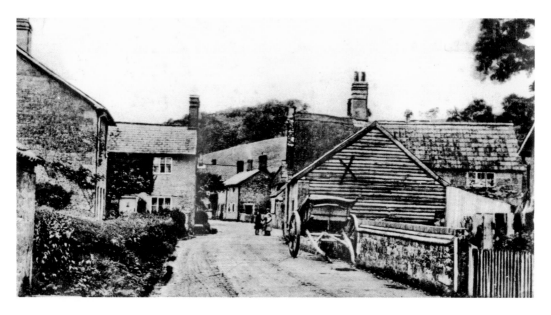

Fovant High Street, 1919

Looking north along the High Street you can see Mrs Truckel's sweet and grocery shop to the right. Many thousands of men from regular and territorial units, as well as Australians, carried out their training in the nearby camp before going into action.

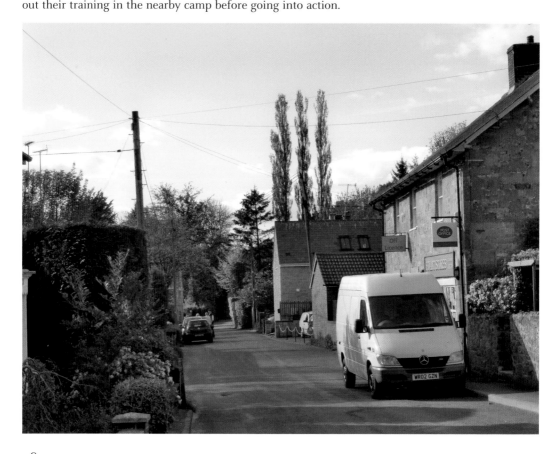

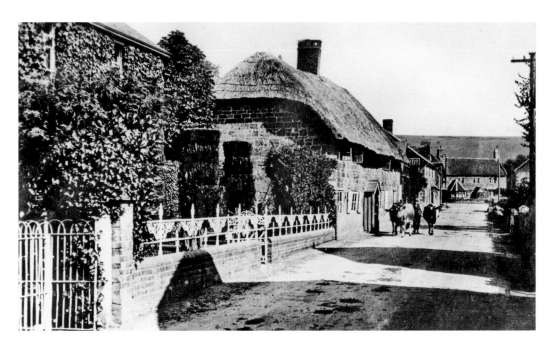

Fovant High Street, 1900s
Looking south along the Fovant High Street we can see, above the now-defunct Crosskeys Arms, the chalk downland where evidence of earlier development includes the Iron Age hill fortress of Chiselbury Ring.

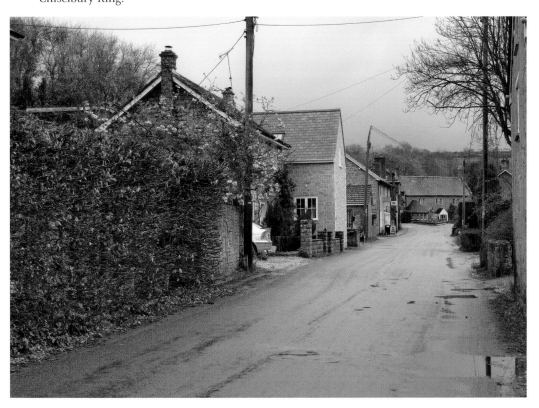

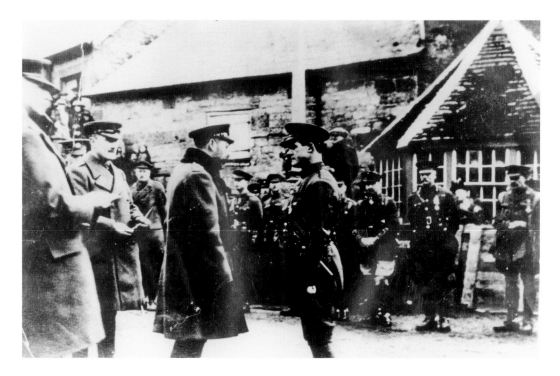

A Proud Moment, 12 February 1917

Sgt Drummer Richard Cooper of the Notts & Derby Regiment is being presented outside the Crosskeys Inn with the Distinguished Conduct Medal, one of a number of decorations being presented by George V for gallantry in Ireland. Today that point would be far too dangerous for such an event, as the A30 and the Fovant High Street meet on a nasty bend.

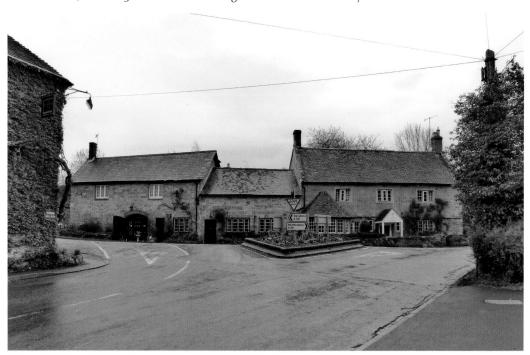

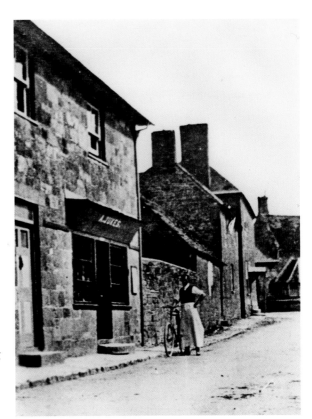

The Village Store, Fovant, 1907
Fovant Stores is the last shop to remain in the village today. Albert Jukes was the owner at the beginning of the twentieth century when this picture was taken. A trade director of 1907 indicates that he also ran the stores in Compton Chamberlayne.

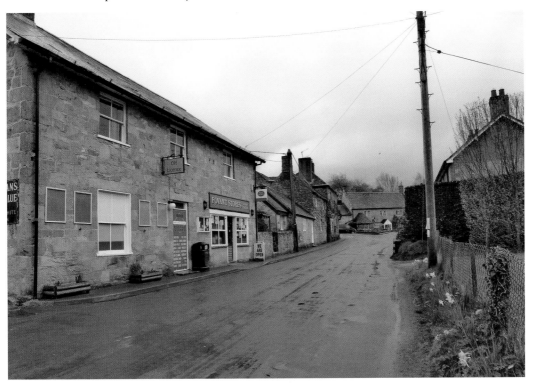

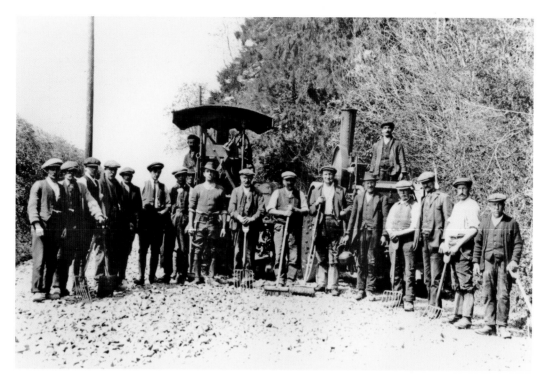

Fovant – Keeping Up the Roads, Early 1920s

Notice how many labourers constituted the gang working on this section of the road – believed to be the upper lane going towards Dinton, shown below, today.

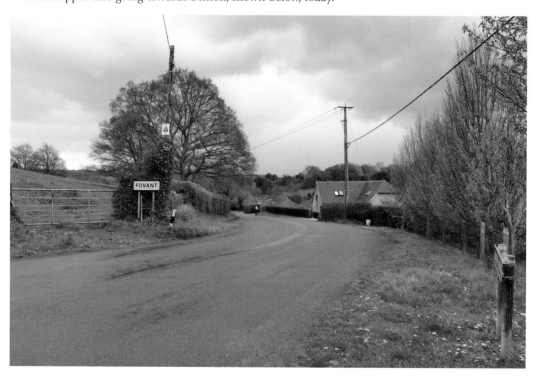

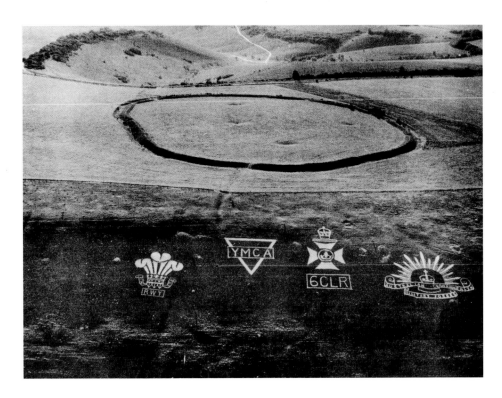

The Fovant Badges

The idea of cutting regimental badges into the downland originated in 1916 with the London Rifle Brigade. Theirs was the smallest, but by the end of the war a wide range of emblems gave evidence of the units situated here. Sadly, because of the expense of maintenance as the regiments have died out or combined, some have to be discontinued, as the second picture shows.

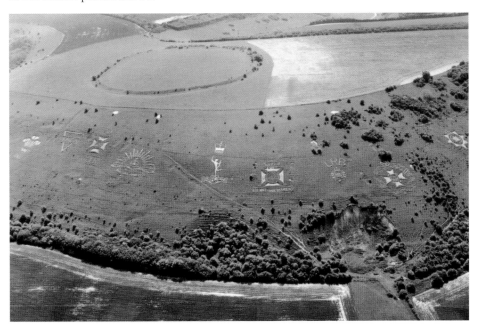

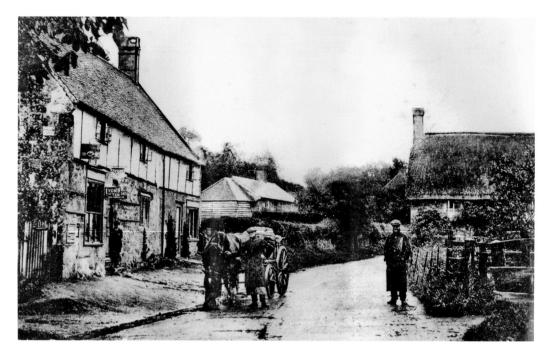

Compton Chamberlayne in the Early 1900s

The village itself, with a population of around ninety-two, has changed very little, possibly less than any other in the Nadder Valley. It displays with pride the 'Best Kept Small Village in Wiltshire' sign, an event it has won on several occasions. The provisions shop on the left remained open until recent times.

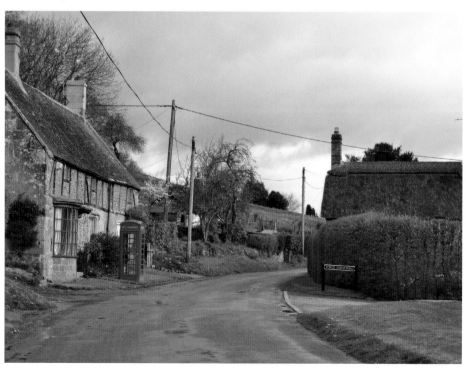

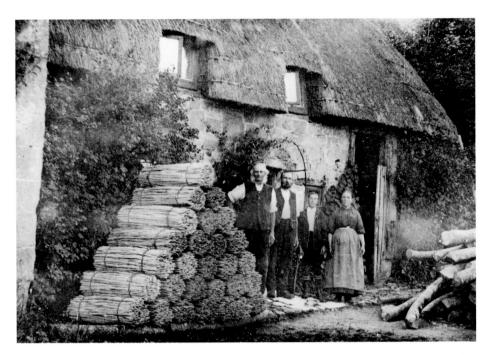

John Wyatt, Maker of Hurdles and Spars

John was born here at Compton Chamberlayne in 1844. He is shown with the products of his trade, which were used for thatching. With him outside their little cottage are his wife Sarah and two of their many children. The lovely meadow below, situated in the centre of the village, is all that is left of his home today.

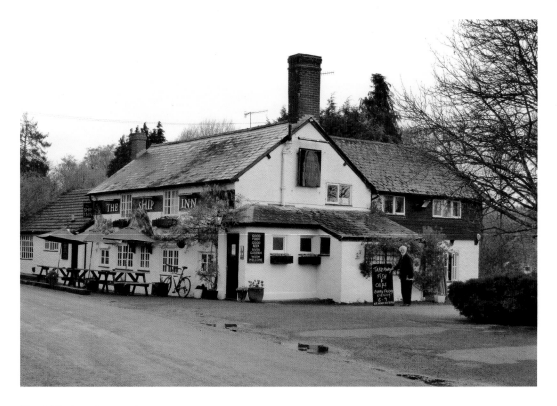

The Ship Inn, Burcombe

The inn, recently visited by Prince William, is shown below during the First World War with Australian soldiers standing in front. They would have come from the large training camp at nearby Fovant. The cottage in the centre was later demolished to widen the road.

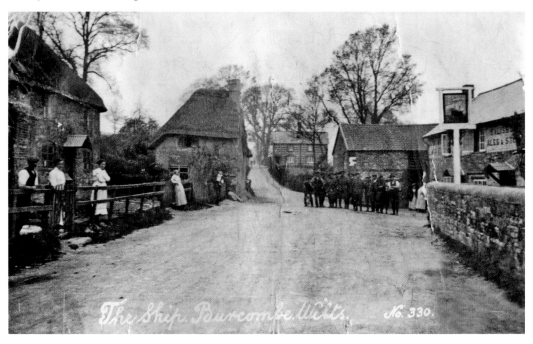

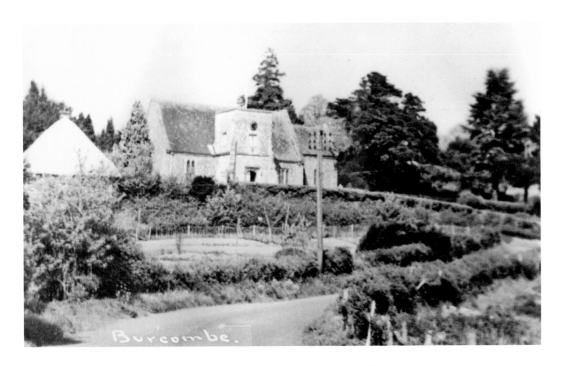

Church of St John the Baptist, Burcombe, Early Nineteenth Century

The church is separated from the village by the busy A30. Unusually its tower is lower than the nave. There is clear evidence of the survival of a Saxon chancel here, with its distinctive long-and-short work on the corners of the external masonry, shown in the bottom picture. The church is now redundant.

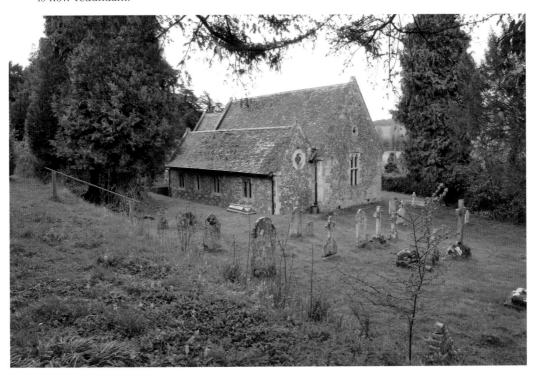

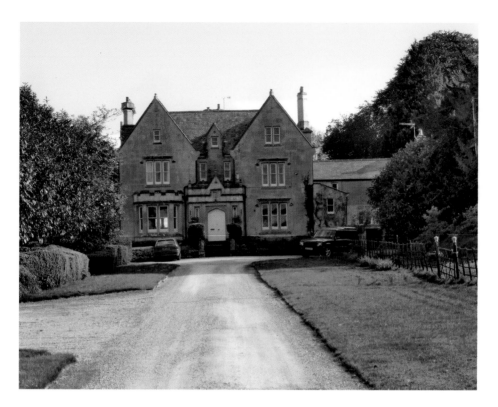

Burcombe Manor

Situated in the centre of the village the manor was reputedly built to house Lord Herbert of Lea, the friend and supporter of Florence Nightingale. It has been described, rather grandly, as 'a Mansion House with gardens and office'. On the downs above the village a more frugal existence can be observed, where the labourers who travel from farm to farm are enjoying tea and a break from threshing. One of this team was later burnt to death when his caravan caught fire in the night.

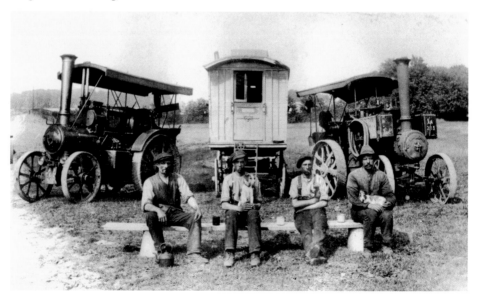

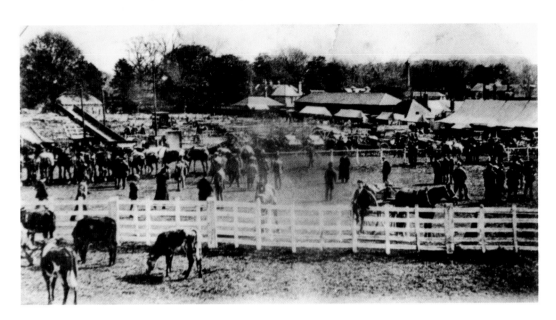

Wilton Sheep Fair, Early Twentieth Century

Sheep fairs have been an institution at Wilton for centuries, moving to their present site along the Avenue to the east of the town at Fugglestone in 1775. In 1883, 40,000 passed through and by 1901 numbers had more than doubled. Today occasional autumn fairs continue in a much more modest fashion.

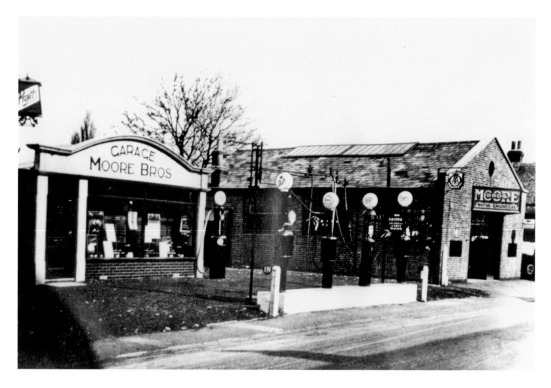

Wilton Motor Engineers, Ditchampton

The brothers William and Henry Moore commenced their automobile workshop around 1924. It was originally a filling station and car stockist, but during the Second World War when petrol was rationed they were not selected as a supplier. In consequence the business was diverted to reconditioning engines. Today the business has been replaced by these handsome terraced houses.

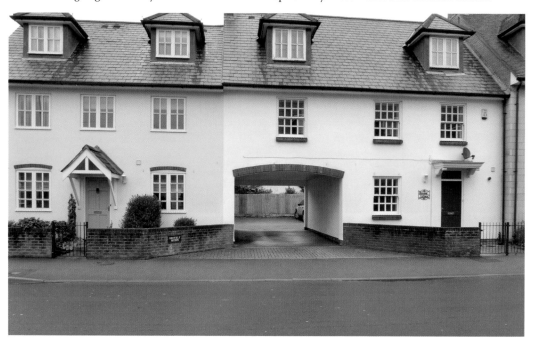

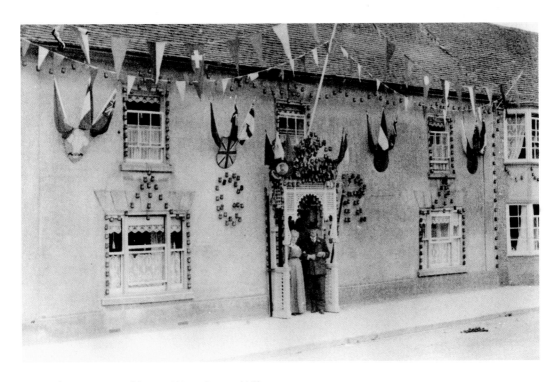

The Moore Residence, West Street, Wilton, 1910

This was the home of William Vincent Moore junior, his wife Agnes and their ten children. William was the owner of the scrap merchant business in West Street. The house, which is now two shops, lies on the corner of Crow Lane. Here it has been decorated to celebrate the coronation of King George V.

John Naish's Felt Mill, Wilton, Early 1900s

Below is the hand felting shop, where men worked in pairs to produce piano hammer felt. A large steam engine was installed to keep the machines turning, including the drive shaft, wheels and belts that can be seen. Today the refurbished mill, with members of the Naish family still involved, imports felt from Germany and has diversified into a whole range of products, from gaskets to indoor bowling greens and hand washing machines.

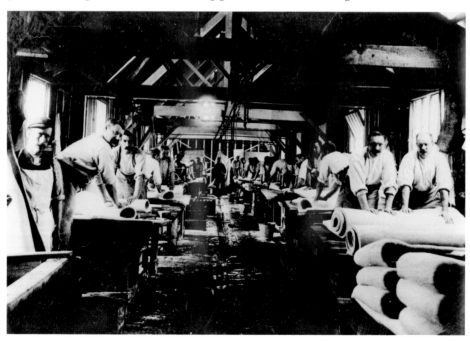

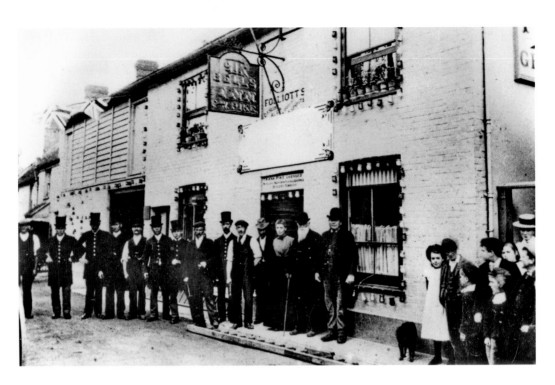

The Six Bells Inn, North Street, Wilton

This very old public house belonged to Folliott's Brewery, now defunct, whose premises occupied the corner of Rollestone Street and Winchester Street in Salisbury. Like so many rural pubs, in recent times the Six Bells began to fail, but reinvented itself as a successful curry house.

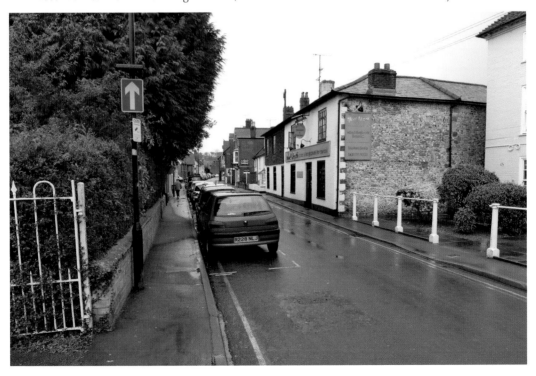

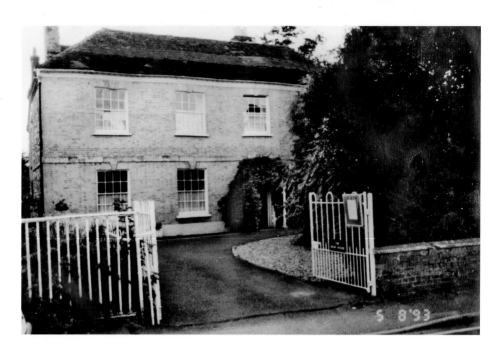

The Moat House, Wilton

Now a private residence, the Moat House was highly esteemed as the home of a very successful Free School. One of its students was the Wiltshire dialect poet Edward Slow. Despite a poor childhood, his widowed mother, a washerwoman, managed to get him a place at the school. Here he was clothed, educated and given a bag of tools to start his apprenticeship as a wheelwright and coachbuilder. Eventually he started a successful business of his own.

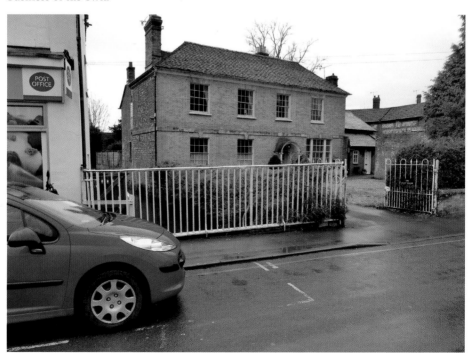